how to create
FANTASY ART for
computer games

Bill Stoneham

A QUARTO BOOK

Published in 2010 by
A&C Black Publishers
36 Soho Square
London W1D 3QY
www.acblack.com

Copyright © 2010 Quarto Inc.

ISBN: 978-1-4081-2762-9

QUAR.FCG
Conceived, designed and produced by
Quarto Publishing plc
The Old Brewery
6 Blundell Street
London N7 9BH

Project editor: Chloe Todd Fordham
Art editor: Emma Clayton
Designer: Karin Skånberg
Additional illustrations: J.P. Targete
Contributing editor: Joe Shoopack
Copy editor: Claire Waite-Brown
Proofreader: Liz Dalby
Art director: Caroline Guest
Creative director: Moira Clinch
Publisher: Paul Carslake

Colour separation by
PICA Digital Pte Ltd, Singapore
Printed in Singapore by
Star Standard (Pte) Ltd

9 8 7 6 5 4 3 2 1

contents

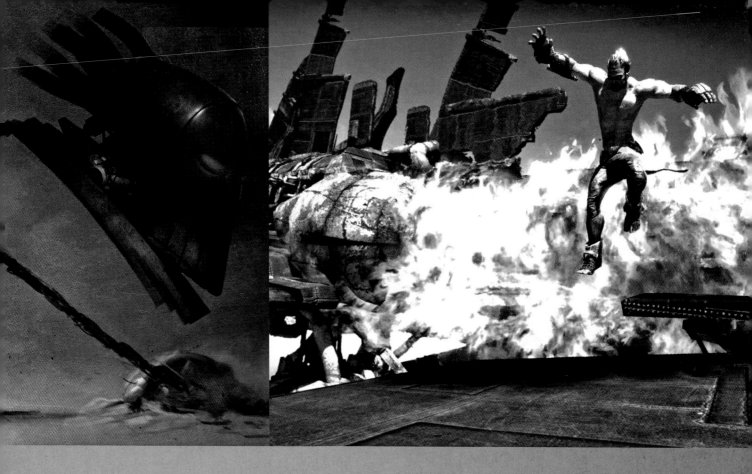

Foreword

How to Create Fantasy Art for Computer Games is an introduction to the compelling universe of digital arts as used in the video entertainment field. The reader will learn the basics, from traditional media to digital processes, used in the creation of fantasy art for computer games.

My work in this field for some twenty years has been a very enriching and rewarding experience and I have worked with very talented artists and creative directors. Creating this book brings together my thoughts and experiences as well as the exceptional talents of several artists in the video game industry.

This book is dedicated to my daughter Eryn Rose and her generation, whose artistic talents may take root in these pages.

BILL STONEHAM

About This Book

This book is arranged in sections that will take you through the stages of producing fantasy computer game art, from selecting the right tools and digital software to developing your concept sketches, through to 3D digital modelling.

Learning how to draw and paint fantasy concept art for video games is the focus of this book. In a chapter called '**Concepts and Techniques**' we take you through the key painting and drawing techniques for creating unique and believable fantasy characters and worlds. If you are eager to let your 2D concepts live on in a 3D life, a chapter called '**Moving Beyond 2D Concept Art**' will give you an insight into the key techniques of the digital modeller, level designer and surface texture artist. You'll find a summation of all the skills learned in these chapters in a section called '**Bringing it all Together**', followed by '**The Gallery**', a selection of work from fantasy game artists from around the world. If you are new to digital painting, there is a section at the back of the book called '**Digital Toolkit**' that will develop your Photoshop skills and inform your software choices.

▼ Concepts and Techniques (pages 12-57)

From sketching on field trips to storyboarding and basic art theories on colour, lighting, composition and perspective, this chapter is crammed with good advice and techniques for developing your own fantasy game concepts for characters and environments. Full-colour artwork is reproduced throughout and, in a unique 'case study' feature called 'In the Artist's Studio', you can look over the shoulder of the artist to find out about his or her preferred working methods and incorporate them into your own way of working. Every example includes a 'golden rule' – words of wisdom from the industry experts.

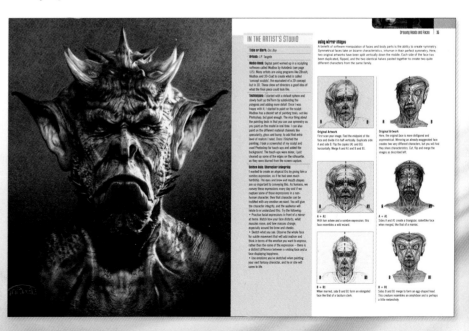

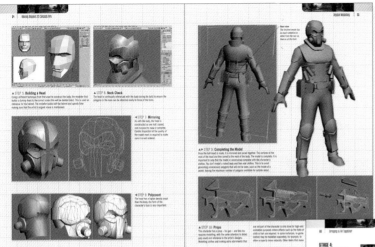

◄ Moving Beyond 2D concept art (pages 58-73)

Learn about the 3D life of your character in focused articles on digital modelling, 3D surface textures and interactive environments. Clear step-by-step instructions will guide you through any complicated techniques.

► Bringing it all Together (pages 74-83)

Industry expert Joe Shoopack from Sony Online Entertainment (U.S.) shows you how it's done in a unique, 'behind the scenes' step-by-step sequence that takes an inital rough for the character Theer from *EverQuest II* through to its final stages.

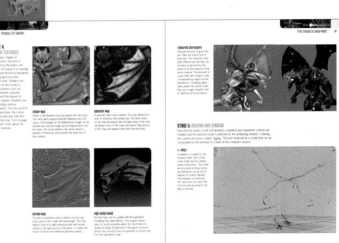

◄ The Gallery (pages 84-107)

Artwork from fantasy computer game artists from around the world is collated in this extensive gallery that will get you inspired to work on projects of your own.

► Digital Toolkit (pages 108-123)

Adobe Photoshop is used throughout the book for digital painting, but there are many alternatives and they're explored in this chapter. Perhaps you're wanting to brush up on your Photoshop skills? Or maybe you're looking to invest in a particular painting program? Unsure about whether to use traditional or digital techniques? This chapter is full of useful advice and refreshers.

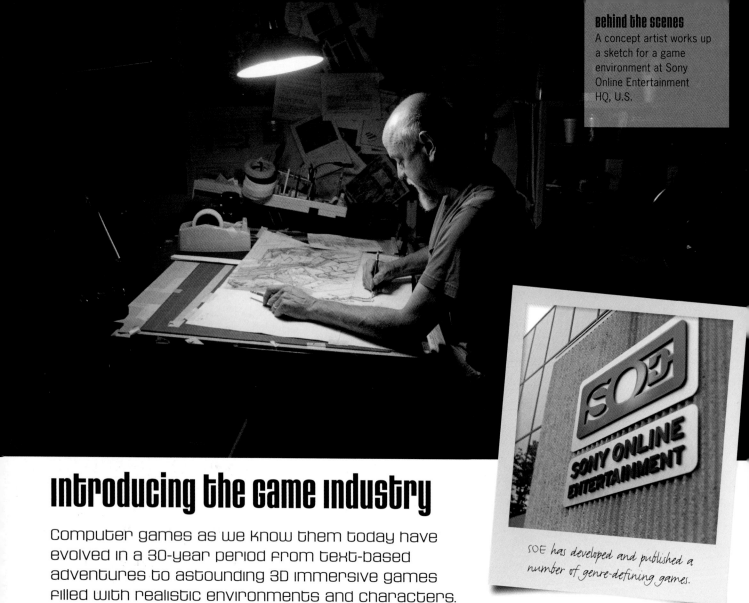

SOE has developed and published a number of genre-defining games.

Introducing the Game Industry

Computer games as we know them today have evolved in a 30-year period from text-based adventures to astounding 3D immersive games filled with realistic environments and characters.

The production process encompasses every stage of developing a marketable game, from initial idea to eventual distribution. The whole process demands a great deal of organization and coordination to get right. With many modern games costing millions to make, deadlines are often absolute, frequently with punitive financial penalties attached to them if they are not met. Skills in personnel and project management come into play – in this way, game development is no different from the manufacture of other consumer goods such as cars. Even with foresight and skilled management, there are usually unforeseen problems. The management of this type of mishap – to reduce its likelihood of occurrence and minimize its detrimental effects – is key.

WHO IS INVOLVED?
At the outset of the design process, there will probably be one or two individuals, or small teams, working on developing the initial ideas. These might be senior designers within the company or specialist idea-generation teams that are tasked with developing new concepts. Once an idea is approved for further development, it might be assigned to a larger team. This team will consist of most of the following groups of people:

DESIGNERS
Game designers are responsible for the look and feel of a game; they generate the concept, story, gameworld and mechanics. They are concerned with the aspects of a game that grab the public's

attention and hopefully make it a success. Under the general term of 'designer', there are sub-roles such as game designer, scriptwriter and level designer. There will also be posts ranging in seniority, from junior positions to leads, who manage many staff.

ART AND ANIMATION STAFF
Art and animation staff give visual form to the designers' ideas, from 2D drawings right up to fully realized 3D models and animations. These visualizations are necessary to develop the game's unique style. These roles can overlap with those of the digital modellers and animators who create the assets to be included within the game.

OVERVIEW OF THE GAME DEVELOPMENT PROCESS

| New game proposals | Multiple idea generation | Concept selection | Game development | Game testing | Game launch |

 Designer
- Develops game concept
- Develops game story
- Develops game levels
- Designs game mechanics

 Sound engineer
- Produces sound effects
- Produces music

 Concept Artist
- Produces concept art
- Develops visual identity of the game

 Tester
- Finds problems
- Gives feedback

 3D Artists and Animators
- Makes and rigs digital models
- Implements in-game animation
- Implements cut scenes
- Generates assets

 Programmer
- Develops game engine
- Prototypes game
- Implements mechanics

 Managers
- Different managers oversee different stages of the process

This diagram is intended to give a general idea of the phases in a typical game-development project. It does not take into account that there may be more than one project running concurrently, or that companies may have different procedures or roles.

SOUND AND MUSIC ENGINEERS
Sound is an incredibly important aspect of modern game design, and the roles of musician and sound engineer are critical. These roles may cover the design aspects of the game as well as the more technical side, when incorporating the soundtrack into the game programming.

PROGRAMMERS
Programmers create the code for the engines that deliver games. Despite coming from highly technical backgrounds, many programmers have a creative aspect to their skills. Though creating the code may be an unforgiving logic exercise, if it is to deliver the sound of a delicate breeze or the effect of a football kicked through the air, the code must be created by a

programmer with a sympathy for the subject. The obvious roles in this category are software engineers and programmers, but these areas can be subdivided – other roles include artificial intelligence programmer or platform designer.

QUALITY ASSURANCE AND TESTING
QA professionals and testers make sure the game works, and that it meets its specifications. Testers have a pivotal role in achieving this, by playing early versions of the game repeatedly to see if it crashes, doesn't work properly, or contains loopholes that allow the player to cheat. Becoming a tester can be a good way into the games industry, if not always a well-paid one. Testers are the kinds of players who can familiarize themselves with every

aspect of a game quickly and have broad knowledge of games to compare against. Feedback from testers can range from identifying simple technical bugs to flagging unsatisfactory aspects of gameplay.

MANAGERS
Developing games is big business, and so the whole apparatus of company and project management comes into play. There will be an overall head of development who may have a project manager, programming manager and art director beneath him. These roles are filled by very experienced staff, as it is their job to oversee the entire project and make sure it is all running well and on schedule.

SO WHERE DO YOU FIT IN?

Before the process of creating art for a video game, there is the game idea. The product of fevered imaginations created by the usual suspects:

■ Boy geniuses with connections – his mum's tennis pro knows someone in the biz.

■ The indie developer – small, secretive cadres of pale-skinned, bloodshot-eyed 'garage dwellers'.

■ Very well-paid game designers, working for massively leveraged game developers.

■ You. (Well, why not?)

CONCEPT ARTIST

As a concept artist, you will be in high demand from the beginning of development. The creative director and game designer will hand you documents that should inform your ideas for concepts – at this stage, what are called 'key concepts'. These will speak visually of the key game conceits and give you information about the game's characters, creatures and environments, showing the palette for each and details of visual cues for levels, such as a great gorge, or a fortress above a forest. Your key responsibilites are to:

■ Provide key concepts for game environments

■ Create storyboards for cinematic cutscenes

■ Create concepts for game assets and devices

■ Create concepts for player characters and key creatures

■ Draw up concepts for non-player characters (NPCs), creatures and other animated entities.

GAME GENRE

Fantasy, as a trope in the video game realm, exists principally in role-playing games that allow players to evolve and enhance their characters. Most fantasy genres involve magic and supernatural abilities, sometimes mixed with fantastic technologies, within a setting that can range from space adventure to medieval warfare. At the core, fantasy games are quests, usually pitting you against an evil power. Under the fantasy umbrella are a number of other genres that games can fall into:

ACTION

With an emphasis on physical abilities, reaction time and coordination, the settings are challenging and dangerous.

■ **Key examples:** The FPS (first-person shooter) *Half Life*. An earlier FPS, *Doom*, was probably the best FPS at the time, pioneering first-person 3D graphics and popularizing the genre.

ACTION-ADVENTURE

An action-adventure game is a hybrid, which makes this the broadest genre of video game. A typical adventure game has situational problems and puzzles. *Myst* (Cyan Worlds) or *Escape from Monkey Island* (Lucas Arts) would fall into the pure 'adventure' definition, with very little or no action. Action-adventure games involve physical reflexes and problem solving, in both violent and non-violent situations.

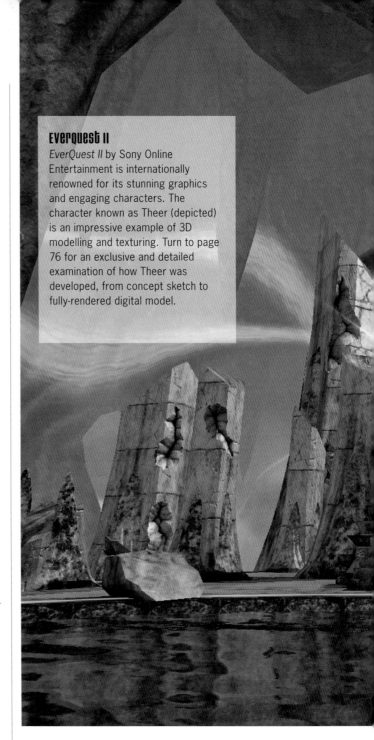

EverQuest II

EverQuest II by Sony Online Entertainment is internationally renowned for its stunning graphics and engaging characters. The character known as Theer (depicted) is an impressive example of 3D modelling and texturing. Turn to page 76 for an exclusive and detailed examination of how Theer was developed, from concept sketch to fully-rendered digital model.

■ **Key examples:** The *Tomb Raider* franchise, the *God of War* franchise and *Uncharted I* and *II* are good examples of the action-adventure hybrid.

ROLE-PLAY

Probably no other genre has captured the enthusiasm of gamers worldwide like the RPG (role-playing game). Coming from story-based genres, these games involve the player(s) in building an avatar and representing their presence in the game world. The RPG genre has more fantasy-based titles then any other category.

■ **Key examples:** MMORPGs (massively multiplayer online role-playing games) are extremely popular. Check out Blizzard Entertainment's *World of Warcraft*, and the games listed at right.

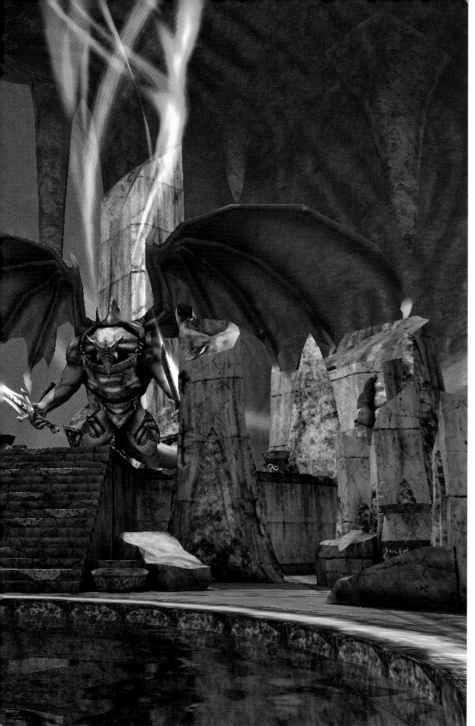

CHECK IT OUT!

WORLD OF WARCRAFT, BLIZZARD
A high standard in artistry provides players with an engaging world. This is the most refined and popular game of its kind, with millions of players worldwide.

EVERQUEST I AND II, SONY ONLINE ENTERTAINMENT
Most gamers were introduced to MMORPGs through *EverQuest*. *EverQuest I* was the first 3D game of its kind to catch on in North America; it features a remarkable level of character and class specialization. *EverQuest II* doesn't disappoint, with its outstanding graphics and impressive character creations.

LORD OF THE RINGS ONLINE, TURBINE
An impressive rendition of Middle Earth with PvP (player versus player) in 'monster play' that allows players to assume the roles of monsters in optional combat.

AION ONLINE, NCSOFT
Set in a high-fantasy world with impressive graphics, especially in the flying combat scenes which are a central mechanic in the game.

AGE OF CONAN, EIDOS
The combat system allows complex combination attacks. At the higher levels, guilds can build cities and keeps.

WARHAMMER ONLINE, MYTHIC
Concentrates on realm-versus-realm conflict, culminating in a siege of the enemy's capital city.

FINAL FANTASY XI, SQUARE ENIX
This game was adapted to MMORPG from the famous series.

STRATEGY
Real-time strategy (RTS) games require skilful planning to achieve victory. These games emphasize strategic, tactical and sometimes logistical challenges. Many games also offer economic challenges and exploration.

■ **Key examples:** Sid Meier's *Civilization*, *Warcraft*, *Starcraft* and *Battle for Middle Earth* are all fine examples.

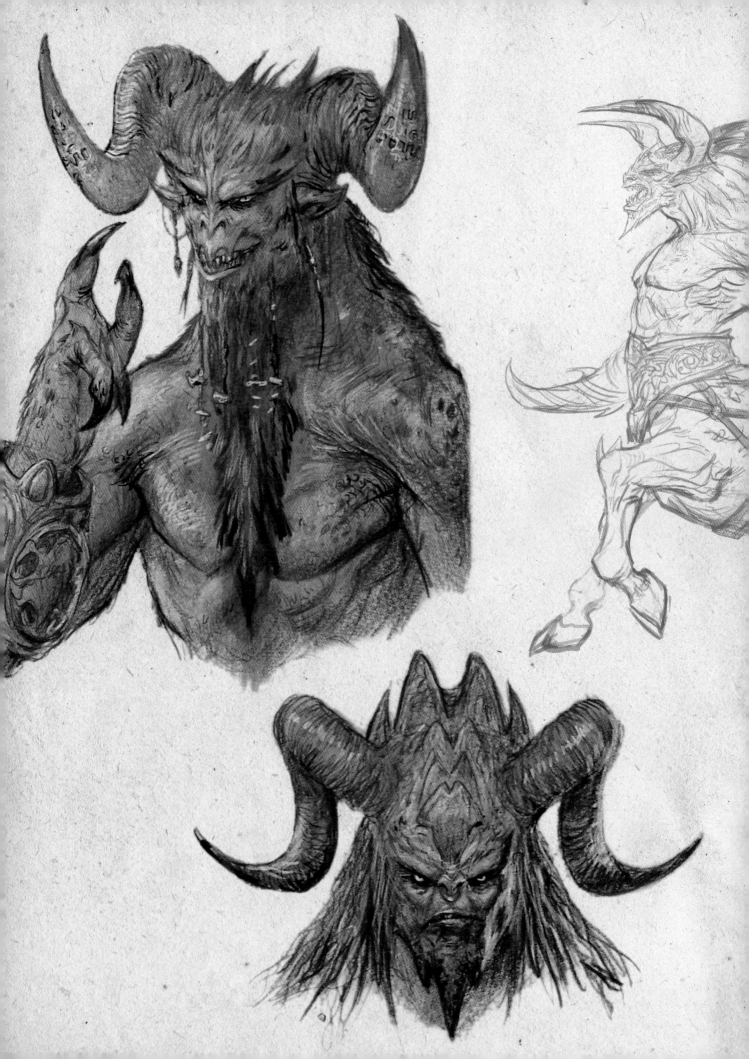

01 CONCEPTS AND TECHNIQUES

Get inspired on your field trips, improve your sketching, build a convincing fantasy character and map out his story in a storyboard. In this chapter, you will learn the essential techniques used by industry experts when they create concept art for fantasy video games.

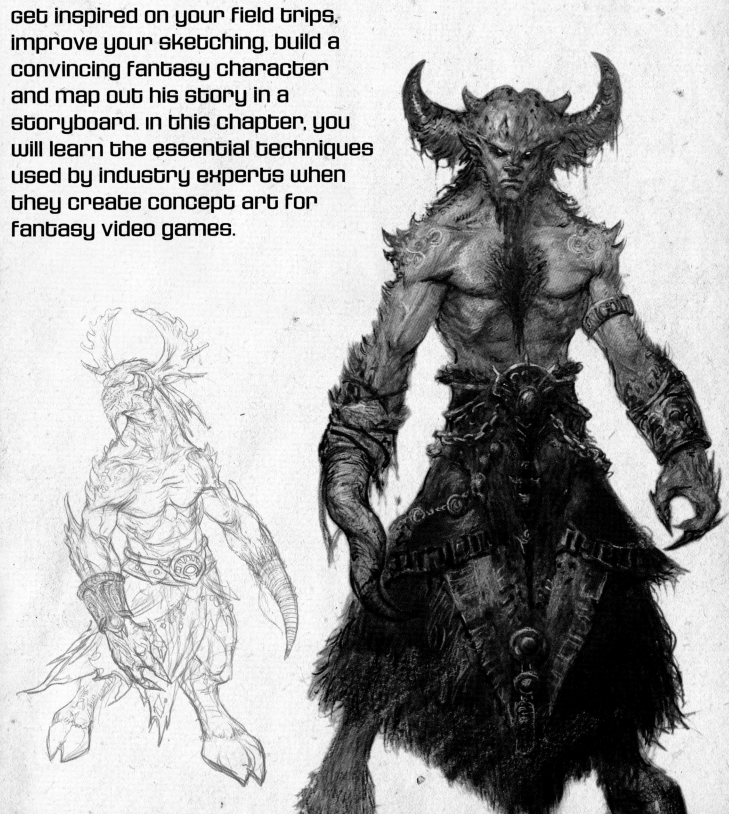

gathering information

Finding inspiration in your surroundings, online and by looking at other fantasy artists' work is the foundation of good concepts and techniques for video game art.

How does a paid trip to Angkor Wat sound? Some game companies have production budgets big enough to accommodate research and development trips, allowing artists to photograph and sketch in places deemed relevant to the visual accuracy of environments in their games. For the artist without the largess of a corporate employer, a trip closer to home can be just as rewarding.

STAYING IN

The internet is the best resource for locating images. Online comic books, fantasy websites, artists' blogs and social media art sites are rich with visual imagery that may provoke and stimulate your own thoughts. Check out DeviantART (www.deviantart.com), one of the top illustration sites for aspiring artists, where you can post your images, get advice and discuss your projects.

GETTING OUT

While good photographic reference can be found on screen, a trip outside is just the ticket for those of you who find it difficult to part with your monitor. You could take a field trip up the coast to a stretch of beach where millions of years of wind, water and shifting geology have created an astounding landscape of tafoni formations worthy of an alien world, or travel to the local zoo and look into the eyes of a monitor lizard to imagine dragons. Examine the architectural motifs in a city's civic centre, picking out the foliate face here and there, or ornate doors worthy of a palace or fortress. City parks offer up some landscaping elements conceived around exotic plants, and while there you can also sketch people in variable lighting conditions. Museums are terrific sources for ancient artefacts, and most have collections from cultures divergent from your own.

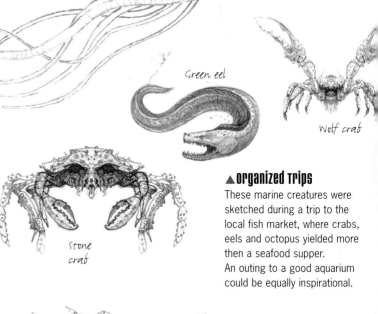

Giant squid

Green eel

Wolf crab

Stone crab

▲ organized trips
These marine creatures were sketched during a trip to the local fish market, where crabs, eels and octopus yielded more then a seafood supper.
An outing to a good aquarium could be equally inspirational.

◄▲ sketching in the field
Scenery sketches made on field trips provide good foundations for settings or backdrop elements for fantasy game imagery. A frozen mountain meadow may be the perfect setting for a half-buried alien ship, or a group of warriors mounted on massive furred centipedes, marching towards a distant mountain fortress.

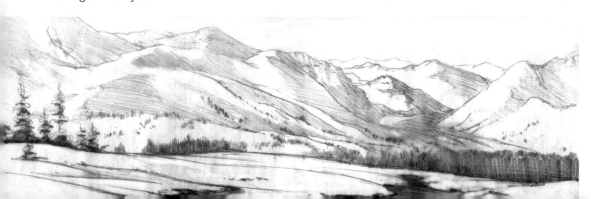

IN THE ARTIST'S STUDIO

Title of work: *The Battle of Dragon Bay*

Artist: Bill Stoneham

Media used: Autodesk 3ds Max and Adobe Photoshop (see page 115).

Techniques: Scale and forced perspective are always on my mind when I examine a landscape; what details of texture and form lend themselves to exaggeration of scale? See page 16 for more on 'Forced Perspective'.

Golden Rule: Carry a Camera
It doesn't need to be a high-end camera, but it's a way to record what sparks your imagination.

This Mayan sculpture provided two variations of a statue. I split the image vertically in Photoshop, duplicated each half, and blended the two identical halves together.

Geese in flight make a nice model for a group of dragons flying. Getting several shots at different angles will help you translate them into dragons.

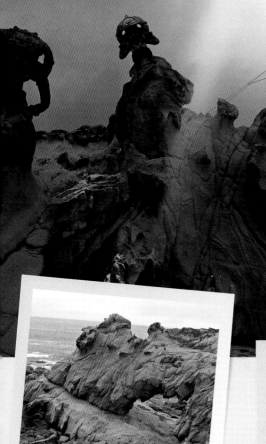

The rock formations provided the base for the idols and lighthouse towers, the staircase and the cave doorway.

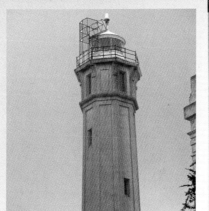

The lighthouse, photographed on a trip to Alcatraz Island, was just right as a watchtower for the archer model.

The street lamp suggested an ancient architecture and was about right for my harbour light, scaled to suggest a gigantic tower with an eternal fire.

The Art of the Moment

Improvisation is creating 'in the moment' in response to the stimulus of one's immediate environment and inner feelings. This can result in the invention of new thought patterns, new practices, new structures or symbols, and new ways to visualize.

This invention cycle occurs most effectively when the artist has a thorough intuitive understanding of the story, and has the tools available to express himself. In other words, you have the sketchbooks, sketching materials, camera and a subject.

EVERYDAY OCCURENCES

Improvisation is all about engaging your imagination and exercising your mind. When travelling on the tube, for example, notice everything around you – colour, texture, how the light changes with the passing stations, and how people's faces change with the light. What if they were visible only in the shadows and had extra appendages? Imagine the tube exiting the tunnel into a fantastic city, change the buildings' appearances, and give the tube train wings. Imagine a forest growing through the buildings, or in the country, visualize a solitary building rising from the forest, incongruous and alien. A similar exercise has occurred in *Mountain Ruins*, right.

FORCED PERSPECTIVE

Try this: Put your camera carefully near the ground, place a familiar object in the foreground, and frame your shot so a landscape spreads across the background. An interesting rock in the foreground will become a monolith. Forced perspective will defamiliarize the familiar and make you think differently.

Sketching Time
Observe the texture and lighting details of the real-life landscape that is all around you. Render it as accurately as you can.

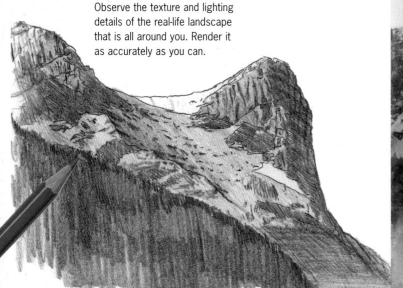

IN THE ARTIST'S STUDIO

Title of Work: *Mountain Ruins*

Artist: Rob Alexander

Media Used: Pencil and watercolour

Techniques: The painting shows the adaptation of a real-world location into a fantasy one, so it was necessary to select an initial source that presented opportunities for transformation. Making sure that the real and fantasy elements integrated seamlessly was a challenge. Picking up on the towerlike structure of the cliff edge, I simply extended it upwards, to suggest that perhaps this had once been a much larger cliff-edge into which a tower was built. The band of snow evident in the original was developed and used to create a sense of depth and to establish the perspective of the tower base.

Golden Rule: Draw From Life
Drawing and painting from life is the best way to understand what you are looking at, as well as the details, subtleties and variations, which only reality can generate. Fill your head with a visual library of buildings, places, people, animals; whatever interests you, based on real world observations. That information is what will allow you to create unique people, places and creatures of your own design that look real, plausible and natural. I have always looked at the world with the attitude of 'it's only half finished, and I get to design the rest of it'. I am constantly looking at things and adding, rearranging or inventing the missing elements. Let the drawing evolve, try not to force anything, but rather listen to the piece, and let it out.

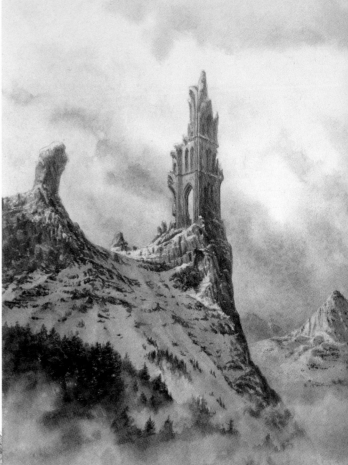

IMPROV EXERCISES

Improving the imagination through exercise is a great entertainment and yields useful imagery for the fantasy artist. Extrapolating from what superficially appears normal or unremarkable is a good technique and will generate fascinating scenarios. Ordinary objects and settings in the real world have inspired all the images on these pages, whether from stock photographs, personal archives or field trips.

In the following sequences, a sheet of tracing paper was placed over a source photograph (1) and the outlines and dominant light and dark shadings of the images were sketched onto it. This emphasis provides a simplified pencil version of the original image (2). Each scene was then broken down visually, and additional levels introduced (3). So the alley in the first sequence gets a trenchlike pit, and the kitchen ceiling and nook wall vanish for the cityscape effect. Let loose your imagination and see what you come up with.

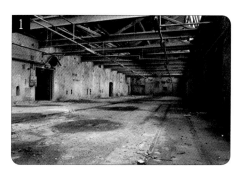 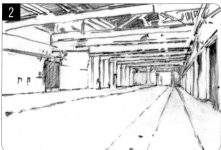 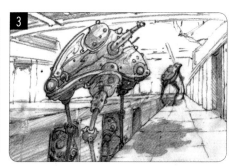

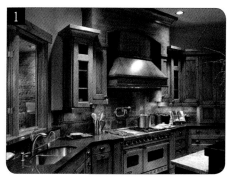 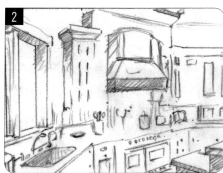 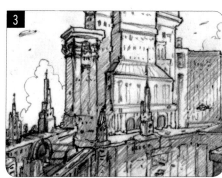

PLAYING WITH SCALE

With a little imagination and paint, you can transform a mundane everyday object into a vast fantasy landmark. If you saw this corroded pier on one of your field trips, you wouldn't look twice. But it is easily transformed into massive sentinel towers from a long-ago drowned fortress or city.

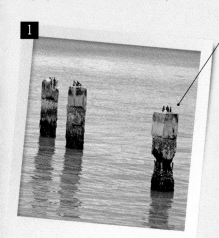

The corroded groynes from the pier are about 25cm (10 inches) tall.

Fill a whole page in your sketchbook with a detail from your chosen image. Take as long as you need. The more time you spend with it, the more you will begin to think of it in a different way.

Colour your image in Photoshop, adding fine details that suggest a sense of scale, like these tiny windows or the surrounding foliage. The 25-cm (10-in) pylons are suddenly a delapidated building in a long-ago war-torn city.

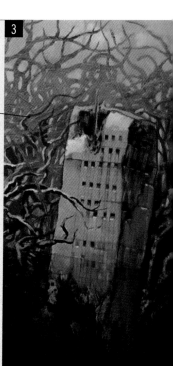

The Art of storyboarding

As a games artist, you will begin work by composing visually, bringing your imagination into the story through drawings, rough thumbnails and storyboard sketching.

Any game project will be based on an early draft of a story. All games have a premise from which the game interaction begins. Some are character-driven, with corresponding stories to help define the characters' roles in the game; others will be driven by plot or environment. Working up initial thumbnails and storyboard sketches means that the later process of creating more detailed concepts for characters and environments will be all the easier.

WHERE DOES THE STORY COME FROM?

The creative director works with the writers who create a script (much like the one below) for the cinematic sequences. The storyboard artist then turns it into a visual script, conveying in sequential panels, through cuts and dialogue, the flow of the action that the cinematic artists will reference.

THUMBNAILS

Thumbnails are a form of doodling, or thinking with your hands. Small compositions are sketched into a set of 'frames' that represent the viewing screen. At this scale, you quickly see what will work and what will not. You are not concerned with nuance and detail, but rather a sense, or presence, of the character or of something in the environment that is graphically compelling. Imagine the story at this stage like a movie trailer, highlighting exciting moments for the game's character, or establishing shots of fantastic environments.

STORYBOARDS

If the composition is for a non-interactive event, such as a cinematic cutscene or introduction movie, more traditional storyboarding is required. This involves composing shots in sequence to the key frames in the scene. Your point of view is that of the camera, so the frames you use represent the screen's aspect. Think of these sketches as a language for storytelling, with a beginning, a middle and an end. At this stage, you are still in pre-production, and your story may be rough around the edges, but your visual language plays an important role in the creative process, allowing you to bounce ideas and sketches off the writers, designers and art directors until a few key scenarios are established. Try out as many variations as you can and let your imagination run wild. On these pages, the author has responded to two sample script treatments with two storyboards.

OCEANIC

You are the captain of a water-going vessel, the Mustekala, a semiorganic piece of tech developed by the dominant species of this universe, a deeply strange octopoid race called the Iko-Turso. You and your seven crewmembers are from the subservient humanoid species, the Nuhi, although you have significant freedom to move around and do as you please. The Mustekala is a trading vessel, and takes you to a number of different environments – drifting rocks the size of planets, gargantuan coral formations, industrial rigs, sea-stars and mazes of intelligent weed. Your job is to buy and sell ink, flammable gases, exotic foods, Nuhi slaves, historical relics and pearls.

Mostly, you will take the POV of the Mustekala's captain, although sometimes you will switch to the perspective of the other crewmembers, and even to the ship itself, especially for aggressive engagements and risky manoeuvres. There are many threats – merman bandits, kraken that could swallow the ship whole, the rebel Nuhi army, even the Iko-Turso themselves. There is a strong impression that your tentacled masters are guarding a dangerous conspiracy.

In one section of the game, you are delivering an ancient idol to the Iko-Turso when one of the slaves you are carrying tells you that it would fetch a higher price if you were to sell it to a member of his own species, the makers of the relic. If you decide to take this course of action, you must work your way out of the Iko-Turso homeworld, a seemingly natural formation of variegated coral, splattered with 'shipwrecks' and abutted by organic-looking structures like octopus arms, which will of course attempt to destabilize the ship. You are pursued by a big, dumb, salty, slobbering, many-armed monster, the like of which you have never seen before. The Iko-Turso really want that relic.

◄ Bringing a script to life

One of your jobs as a concept artist is to visualize the scriptwriters' treatment. This complex new game idea combines vehicle control, leadership, moral decision-making and old-fashioned monster fighting. It takes place in a vast universe mostly constituted of water, although there is a prevailing myth that there is an 'outside', possibly a place more like our own universe. Working out whether this is true or not is one of several avenues you might take when you begin to explore the story. Two very different examples are shown over the following pages.

OCEANIC STORYBOARD

If you have a descriptive, well-written script to start with (like this one did), it works well to fuel the imagination. Point of view (POV) is particularly important in this game and the frames show the game play from the viewpoint of the captain, crewmen, even the ship. As a result, the gameplayer is able to 'see' all key elements of the action.

The captain's POV is key, as he witnesses the important activities of the ship.

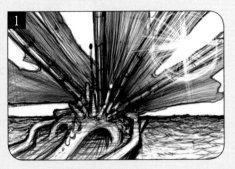

Desc: The Mustekala unfurls its membranous sails.
POV: Captain.

Desc: Crew members get the ship underway.
POV: Captain.

Desc: Approaching land mass (a giant floating rock).
POV: Captain.

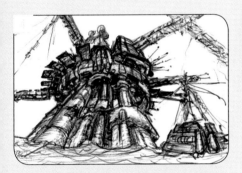

Desc: Massive industrial rig – one of the stops of the Mustekala on its trade route.
POV: Crewman.

Desc: Stop to take on flammable gas.
POV: Crewman.

Desc: Diving for pearls.
POV: Crewman.

The Mustekala itself is a great underwater vantage point.

A crewmember's viewpoint is important as the player will be involved in all the action.

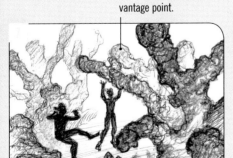

Desc: Diving among huge coral formations. This is an oceanic haven where sea life has reached dramatic proportions.
POV: Mustekala.

Desc: Trade negotiations with another tribe.
POV: Crewman.

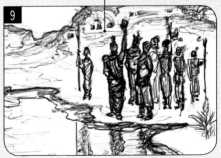

Desc: Departure after successful trade.
POV: Crewman.

GARGOYLES STORYBOARD

Game scripts, like the one on the opposite page, can be character-driven. In this case, it might be worth conceptualizing the character before you begin plotting the story. Although it is not evident, this artist designed nearly a dozen faces and bodies before starting on the storyboard (birdlike, reptilian, hoglike and so on). Research and development is an important phase of any fantasy art.

Dramatic perspective creates depth and interest.

In the frosty dawn of 14th-century England, a monastery stands in peaceful silence.

The grotesque forms of gargoyles stand poised atop the tower. Waiting... Watching...

A mouldy tile gives way. The gargoyles suddenly spring to life and launch from the rooftop.

Peak moments of action are shown to highlight key visual elements of the story.

Having risen before light, Brother Tybalt gets an early start tilling in a distant field.

The gargoyles attack, hurling masonry and defiling the shrines. No one is left alive.

Brother Tybalt returns home to find the monastery desecrated and his brethren dead.

On the road to London, there is a confrontation with the gargoyle clan and a particularly humanlike creature.

Enter a faery, a radiant creature with a gift of changing the beasts back to stone with a touch on the forehead.

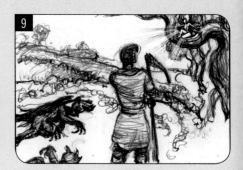

After a successful repulsion of the enemy, Brother Tybalt wonders if his new ally can be trusted.

GOLDEN RULES FOR STORYBOARDING

■ KNOW YOUR STORY

The scriptwriter has usually taken a lot of time to work out plot, characters and the environment that they reside in. Read the story, and make sure you understand it.

■ DO YOUR HOMEWORK

To visualize a story, you've got to first develop the characters, creatures and environment. This requires research and development that may include study of a specific time period (14th century), or place (the sea).

■ KEEP IN MIND PLAYER POV

Try to assume this viewpoint at all times so that you can get a feel for what the player is looking for or might be interested in.

■ SHOW KEY ACTION

Use a highlighter to separate out the visual descriptions and the dialogue sequences in the script you are storyboarding. Find the key visual element in each and then begin to structure them so that there is a beginning, middle and end.

GARGOYLES

In the frosty deepwoods of 14th-century England, a monastery is attacked. The many gargoyles decorating the roof become, without warning, animated. They fly around, murdering everyone, defiling the shrines, and hurling masonry about with reckless abandon.

You play Brother Tybalt, a non-scholastic monk who has spent the day tilling in the fields some miles away. When you return to the monastery, you only see the effects of the destruction and realize that you are perhaps the only survivor. The gargoyles have all disappeared, apart from one or two, whom you murder in a blood rage. Immediately, you pack supplies and journey to a small milling village nearby. The devastation there is unspeakable. You resolve to go on the road, and kill every last stinking gargoyle in the land.

The road might take you as far as the city of London (where some of your questions will be answered). In a typical episode, you are ambling along a country lane at noon, when a 'cloud' of flapping gargoyles swings across your path. The gargoyles are grey (still stony) and screech a lot. Individually, they jerk about chaotically, continuously angry, but in a group they are fairly consistent. This little gang have clearly ransacked a farm, for they are wielding sickles, axes and haymaking forks. A large, suspiciously human gargoyle swoops down with a scythe. This is early in the game so you may only have a stick. You must beat off the gargoyles and prevent them from sinking their mouldy stone teeth into your flesh.

Some gargoyles sit, spectating, in the hedgerows. Others rage in, chittering, clawing at you. You bonk one on the head, and steal its sickle. A weapon. You must slice away at the gargoyles, not necessarily to kill them, but enough for them to apply their efforts elsewhere.

Helping you – leaping out of the hedgerow – is a faery! A winged creature of radiant emerald who, unlike you, is able to launch himself above the gargoyles and touch a kind of dust to their foreheads, whereupon they revert to inanimate stone. This is a great help. Together, you are able to overcome the gargoyles (quite a few fly away, including the large, human-seeming character). You are surrounded by frozen monsters with rictus grins, and a heap of potential weapons. But is the faery to be trusted? An important question – this lithe, delicate, confident creature has resolved to join you on your quest.

doodling and sketching

There are two principal visual areas in game design and concept art: Characters and environment. The process of developing the visuals for these areas in a game usually involves drawing.

Sketching is the hard copy for ideas. Keeping sketchbooks on hand for scribbling is always a good idea and creating thumbnails or doodles around a story under discussion is a good way to start collecting a catalogue of images.

WHERE DO I START?

With an idea for a single place or object, you can begin building worlds and their inhabitants. Organic shapes are always a good starting point for loosely sketching creatures, since they are primarily rounded masses. A sack of potatoes is one example of a mass, with coarse-textured skin and lumpy bones beneath. Manufactured shapes offer a variety of possible combinations; your imagination will reassemble the pieces to construct buildings, starships or mechanized monsters. Alternatively, you might sketch while watching a movie, allowing fragments that attract your attention to flavour the drawing.

THE YOGA OF ART

When you doodle or sketch, the eye registers virtually everything. Even though you are not conscious of every face or object you see, their images reside in the brain's 'flash' memory. Doodling is the window into those memories and the sketchbook your journal of adventure into that realm. Use the pencil in your hand like a wand or conductor's baton and loosely wander over the page, changing pressure, making darker and lighter lines. Shapes will begin to emerge, and the window opens.

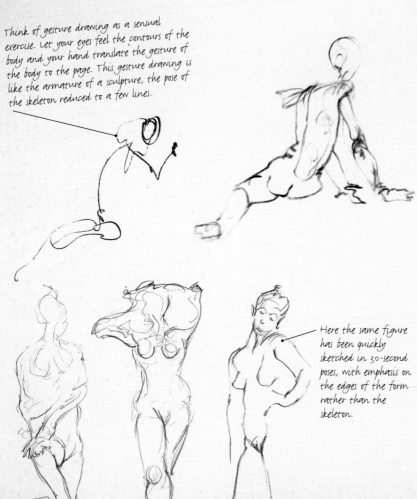

Think of gesture drawing as a sensual exercise. Let your eyes feel the contours of the body and your hand translate the gesture of the body to the page. This gesture drawing is like the armature of a sculpture, the pose of the skeleton reduced to a few lines.

Here the same figure has been quickly sketched in 30-second poses, with emphasis on the edges of the form rather than the skeleton.

GESTURE DRAWING FIGURES

Gesture drawings are quick studies that allow you to loosen up and let your hand feel what your eyes see. Essentially, gesture drawing is a biofeedback through your fingers and the tip of the drawing tool into your artistic brain. Do this enough with the same figure or object and you will begin the process of building a drawing memory.

When you look at a figure for the first time, or see an object in a certain light, you notice its contours and its mass, its light and shadow, and how it all changes with movement. Drawing the figure quickly and loosely gives a sense of foreshortened mass and weight. The hand that is drawing carries the gravity of the figure through the pencil and onto the paper, using a heavier line where more mass moves with gravity; larger circles for thighs and hips. Within the first few seconds, you should have every part of the object indicated on the paper. Darker shadings convey mass; lighter, looser lines suggest the extremities, such as hair.

CONTOUR DRAWING

Variations of this technique can be used for contour drawing. Focus your eyes on a point along the outline of your object. Place the tip of your pencil or charcoal on the paper and feel the point as though it too were on the edge of the object. Do not look at the paper. Move your eye slowly along the edge of the object and your pencil slowly on the paper.

MIX AND MATCH SKETCHES

The tools in Photoshop allow you to break and reassemble pieces just as you might with plastic model kits for boats, cars and battleships, where whole new objects can be assembled from disparate parts. Photoshop's tools can also be used to transform a simple building doodle into a whole city, or to adapt a few sketches of sea creatures into the upper torso of a new monster. Turn to page 24 for an example of this technique.

A doodle that starts life as an amorphous squiggle may suggest a clump of rock or a tooth, which in turn brings to mind a jaw and the shape of a dragon's neck.

Contour lines describe the gestures of wings and limbs and give movement to these flying dragons.

You may make a more deliberate doodle when something captures your curiosity – in this instance, considering how leathery wings might drape over a thin-limbed flying creature.

One thing leads to another, and in this case, doodling while thinking about mythical creatures resulted in this mutant multihead with its weird clamp devices, ready to shift a limb or head to a new location.

mix and match elements

You can easily make a more complete design by mixing and matching your rough doodles. The structure of the rock pinnacle was incorporated into the watchtower in this landscape design – even the scribbles from an early sketchbook have been worked into the scene to represent a huge army waiting to traverse the river and attack the tower. Nothing goes to waste, and your doodles can be subject to the drafting process, too.

This doodle of a crowded marketplace conjures a feeling of claustrophobia, and was perfect for the stranded army in the final concept design.

The still life study of a rock pinnacle was adapted to create a watchtower in the final design.

MAKING A COMPOSITE IMAGE

The real pleasure with doodles and sketches is reassembling them into completely new creatures or environments. Software manipulation tools are perfect for this Frankenstein approach to art in a digital age. Mixed together, the writhing tentacles of a medusa jellyfish, the fierce eye of a cephalopod, the leg of a predator, and the trunk of a minotaur – like a witch's brew – yield the new monster. Each piece is its own layer in Photoshop, giving you complete control over how you transform, scale, rotate and blend the part onto the new creature.

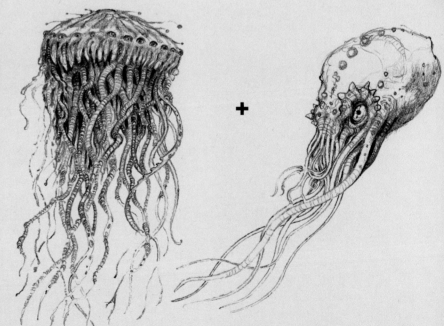

step 1

Think in terms of body parts. Riffle through your sketchbooks and choose a suitable sketch for a head of a fantasy character. In this case, a medusa jellyfish was selected.

step 2

Now look for facial features. They might complement or contrast with your chosen head. Here, the eye and brow of the cephalopod, with the tentacles streaming off them, are cut and mirrored, making the face over the medusa jellyfish.

PRESENTING YOUR IDEA

When presenting a client with concept sketches, it is a good idea to show as many variations as you can in the form of refined thumbnails. This particular client selected aspects from both variations for the final character. You may then be asked to develop more drawings of the character in rotation.

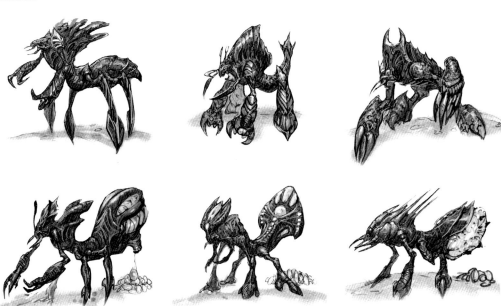

the soldier ▶

The large pincers, slender torso and short tail make the soldier a fighter. He's always on the attack.

The Queen ▶

The queen is more impressive in both visual design and functionality. Her larger antennalike appendages serve as her main communicator to the rest of the colony. Her large back half is a birthing organ from where she will lay her eggs. The design suggests the character may not be as mobile as the soldier, but the queen serves an important purpose in the game play and in the larger scheme of the story.

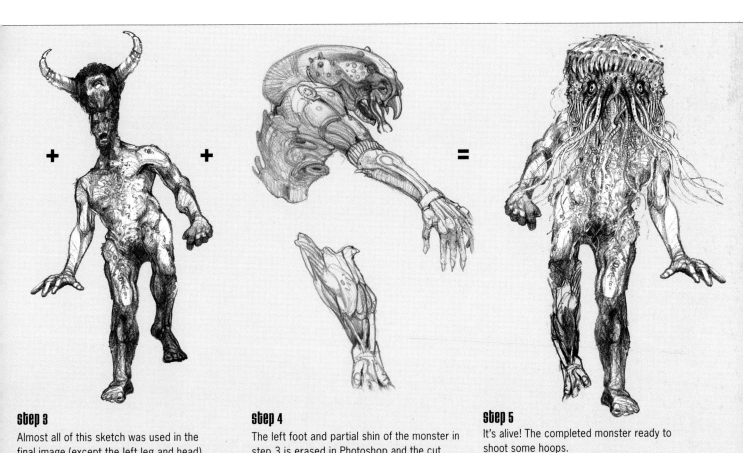

step 3

Almost all of this sketch was used in the final image (except the left leg and head).

step 4

The left foot and partial shin of the monster in step 3 is erased in Photoshop and the cut portion of this predator's leg is placed over it.

step 5

It's alive! The completed monster ready to shoot some hoops.

conceptualizing the figure

Almost all fantasy illustrations contain figures with human traits. To draw any distorted or adapted versions of the human form, you must first make yourself familiar with the normal human form.

Take every opportunity to study the nude human figure through life drawing classes. Pay special attention to the body's proportions and try to see how the important joints work. Study the bone and muscle organization and look at the distribution of mass around the body – the way the various masses respond to gravity in different poses. Think always about how the parts of the body work, and how all those bits function together. There are various books on human anatomy; ask at your local bookshop.

Once you are completely familiar with how human bodies work, you can start to experiment with abnormal ones. Exaggerate, adapt and accentuate critical features such as limbs, muscles and facial features, and you will arrive at some very strange creature concepts that nonetheless have a foothold in reality, and therefore will appear all the more convincing to your viewer.

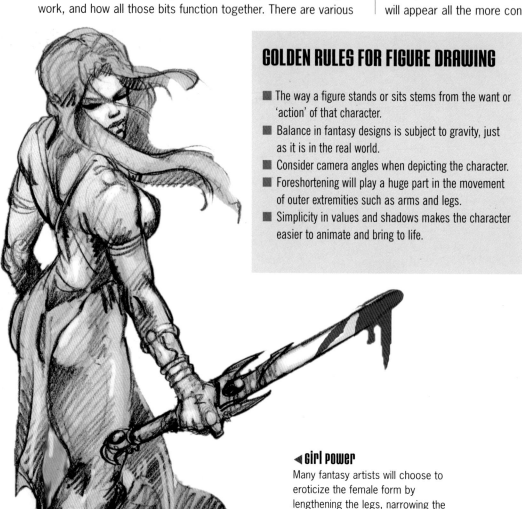

GOLDEN RULES FOR FIGURE DRAWING

- The way a figure stands or sits stems from the want or 'action' of that character.
- Balance in fantasy designs is subject to gravity, just as it is in the real world.
- Consider camera angles when depicting the character.
- Foreshortening will play a huge part in the movement of outer extremities such as arms and legs.
- Simplicity in values and shadows makes the character easier to animate and bring to life.

◀ Girl Power

Many fantasy artists will choose to eroticize the female form by lengthening the legs, narrowing the wrists, ankles and waist, and exaggerating the bust. It's by no means a prerequisite for your design, and you shouldn't be confined by this convention. This Amazon is well-built and muscular as well as voluptuous. Her posture screams of victory and her blood-stained weapon implies she is a force to be reckoned with, for male and female adversaries alike.

Female Amazon

Males and females share the same vertical proportional measurements, but in women the pelvis is larger, resulting in wider hips and a more pronounced waist. Drawing the figure from the front, back, side and above will make you more aware of the subtle differences between the classic male and female forms.

Male Warrior

In the male, the shoulders are much wider and the legs, arms and torso have more muscle. You can show strength quite easily on an upright figure, but it's often better to suggest it: Give your character a pose, like this stealthy warrior, and think about how the muscles react to gravity and pressure.

Fantasy Beast

How many recognizably human features does a fantasy beast require for the viewer to identify with it? Often very few, but do ensure you maintain some semblance of humanity or your creatures will lack integrity. This beast has the muscular torso and head shape of a man and stands upright.

GETTING INSPIRED

Inspiration for figure conceptualization usually derives from watching countless action movies. There are numerous resources in movies from character dress to weaponry. What better cheap resource is out there than being able to pause a movie and view your famous fantasy character from numerous angles. Lighting, shadows, the space a character takes up, muscles in action — it's all there to study. Your imagination is the only limit.

front	back	side	top

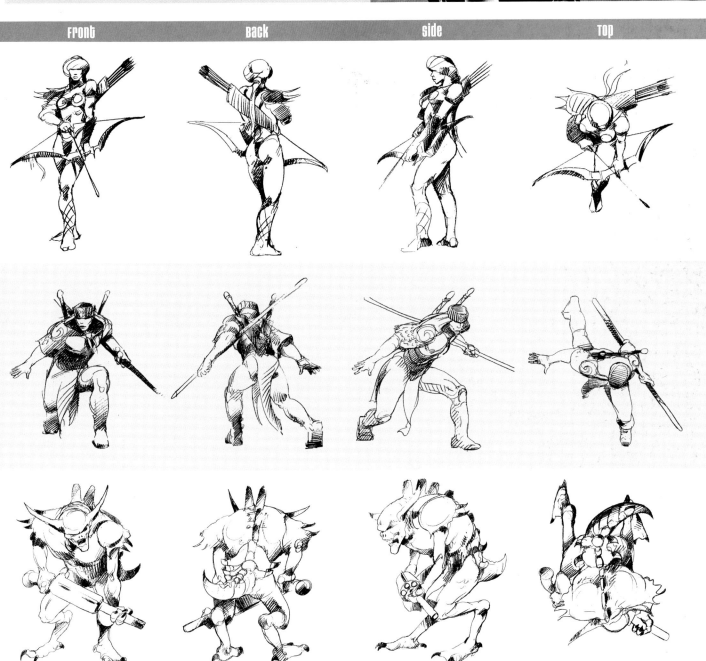

posing the figure

Any character sketch begins as an anatomical underdrawing that will change when the character changes position or mood. To animate these characters, you first have to understand how the body works.

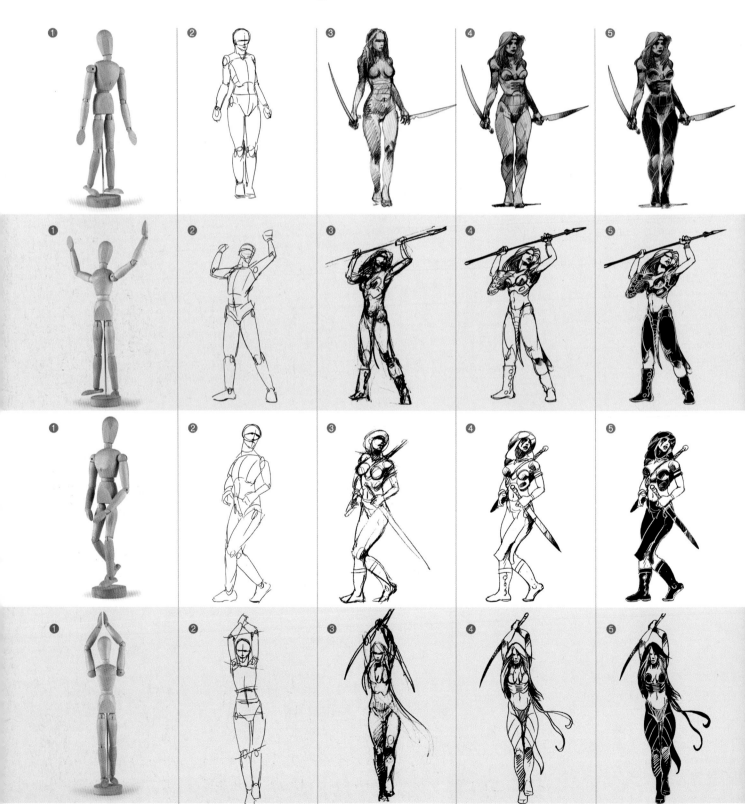

Your figure will only look convincing if you have correctly planned the posture and distribution of body mass. The anatomical underdrawing (a simplified version of the body's shapes in a given pose) is key to your success. Follow these simple instructions:

1 Pose an artist's mannequin.
2 The human form is comprised of shapes: circles, squares, triangles. Sketch out the shapes you see: the skull, ribcage, pelvis, upper and lower legs, arms, etc.

3 Create a line drawing by sketching over and around the shapes.
4 Build up your pencil sketch to create a more detailed tonal drawing. Start to think about the muscles and where they are. How would the light fall on them? You'll now begin to flesh out the flat line drawing.
5 Create a final draft lined out in ink. Then, scan the drawing and enhance it in Photoshop, Illustrator or the computer program of your choice.

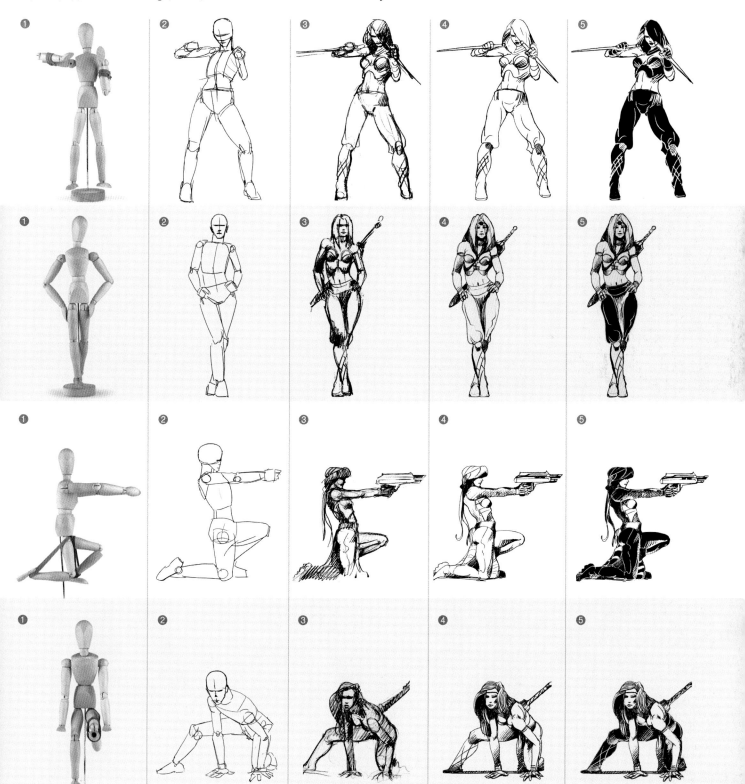

clothing the figure

What does a well-dressed zombie wear? That is up to you and the designers, which makes this aspect of character and creature development so exciting.

Your characters need a wide range of accoutrements appropriate to their genre and rank throughout the game – although monsters do not always need extra gear. Most humanoid characters need tight-fitting garments that emphasize their physique and sex appeal, and gear that either enhances the figure's visual profile or supplements its physical power.

GENDER ISSUES

Garments, weapons, hair, body piercing, tattoos and all manner of horns and thorns can be appended to a character's body to emphasize its intentions, personality and gender. A traditional male character is physically fit with rugged features, a facial scar, a cryptic tattoo and well-muscled arms. An equivalent female would have somewhat lighter gear, a good deal more exposed flesh – for the vulnerability-versus-strength persona – and no headgear to hide the face and hair. This is the convention, but in fantasy everything goes. Check out these space chicks for inspiration.

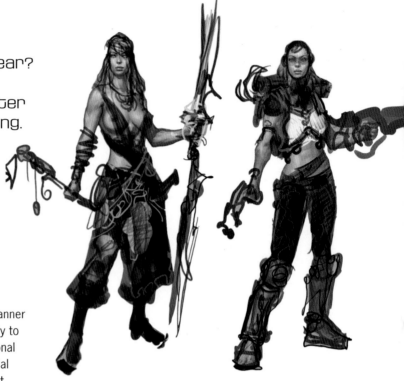

Desert Dweller
Straight out of a post-apocalpytic desert world, it's the assymetrical clothing design that informs this character's ruggedness.

Rebel Gunman
The costume of this gun-toting tough girl is more functional than decorative. The backpack, thick boots and knee pads suggest this is a 'not-so-distant-future' design.

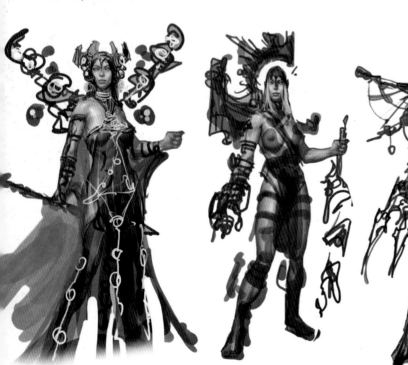

Princess
This lavish gown makes a strong silhouette. Being royalty, it's imperative she stands out, especially as visibility plays a key part in most game worlds.

Tech Warrior
50 per cent sci-fi, 50 per cent fantasy. Combining genres creates diversity in your designs and entices more gamers who admire specific genres.

Goth-punk Tech Warrior
This design is a wild mix of sub-genres, from gothic to punk to sci-fi. The bleached hair and white leggings contrast with the other design elements.

Warrior Girl
You might expect this young warrior to be an inexperienced fighter. Don't be fooled! And don't manage viewer expectations too carefully; surprise works a treat.

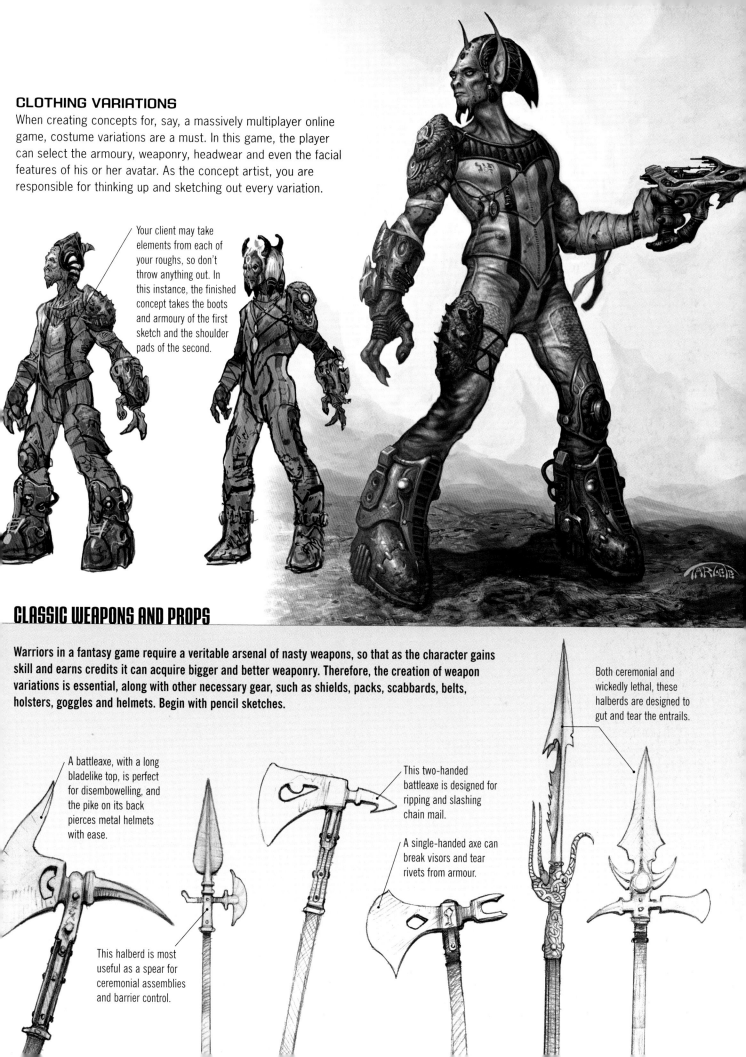

CLOTHING VARIATIONS

When creating concepts for, say, a massively multiplayer online game, costume variations are a must. In this game, the player can select the armoury, weaponry, headwear and even the facial features of his or her avatar. As the concept artist, you are responsible for thinking up and sketching out every variation.

Your client may take elements from each of your roughs, so don't throw anything out. In this instance, the finished concept takes the boots and armoury of the first sketch and the shoulder pads of the second.

CLASSIC WEAPONS AND PROPS

Warriors in a fantasy game require a veritable arsenal of nasty weapons, so that as the character gains skill and earns credits it can acquire bigger and better weaponry. Therefore, the creation of weapon variations is essential, along with other necessary gear, such as shields, packs, scabbards, belts, holsters, goggles and helmets. Begin with pencil sketches.

Both ceremonial and wickedly lethal, these halberds are designed to gut and tear the entrails.

A battleaxe, with a long bladelike top, is perfect for disembowelling, and the pike on its back pierces metal helmets with ease.

This two-handed battleaxe is designed for ripping and slashing chain mail.

A single-handed axe can break visors and tear rivets from armour.

This halberd is most useful as a spear for ceremonial assemblies and barrier control.

Drawing Heads and Faces

The face defines most fantasy creatures, and is the perfect place to begin building a character's persona.

Large eyes on a face with a small mouth and nose convey openness and vulnerability, whereas a face with small eyes in proportion to the nose and mouth suggests cunning and mischief. The scale, shape and size of your character's main facial features (nose, mouth, eyes and ears) will give the player clues to its past and personality. More subtle details such as lines around the eyes and mouth, a scowl or a half-smile will give the character depth and integrity. In fantasy art, you can exaggerate facial aspects to some degree (with digital models, there are no limits to the possibilities), but it helps to get the standard human head shape and proportions right first. Many famous Star Trek aliens such as the Klingons or the Romulans started as concepts based on a human face.

The schematic drawings shown below and right will help you to identify the position of features, and their relationships to each other. Follow these diagrams carefully and practise drawing the head and face in rotation, because at different angles, the arrangement of features will change.

Exaggeration is a compelling technique when creating fantasy characters and creatures. When you have mastered the basic human head structure, begin to experiment with the size and shape of the features. Give some thought to the creature's body, too. Will it complement the characteristics in the face or contradict them? A baby head atop a monstrous body, for example, will convey a dangerous physicality; a huge head for a tiny body might represent a mad intellect, out of touch with reality.

Front view: Showing the planes of the face.

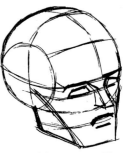
Rotated three quarters: The line of the jaw and cheekbone converge.

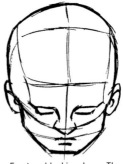
Front and looking down: The forehead line is in the centre.

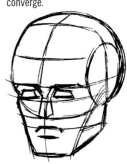
Note the ellipse for the ear and the right angle of the jaw.

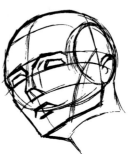
Head tilted to the right and back, showing the underside of the jaw and chin.

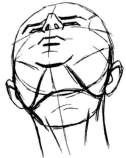
Head tilted back, showing the neck and chin and foreshortening the face.

▲ The Head in Rotation

Drawing a grid helps you to visualize where features sit when you see a head from different angles. Using the vertical axis and the horizontal divisions, you can plot the position of features as the head turns.

AGEING YOUR CHARACTER

A child's forehead is high, the nose very small and unformed. Young people have firm features and often rounded, 'puppy-fat' flesh. With age, bones and muscles are more visible; gravity pulls downwards on the skin, pouching at the ridges of the sockets and corners of the mouth. In men, the jaw and brow are typically heavier than in women.

FEMALE

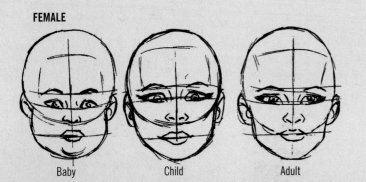

Baby Child Adult

MALE

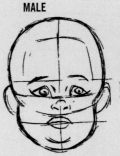
Baby

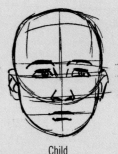
Child

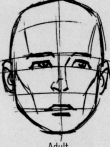
Adult

BUILDING CHARACTER

The face and head are the first parts of a character that a viewer reacts to, so explore different ways to visualize the individual. Facial structure and expression are vital in the descriptive process. Each example shown here combines different elements to capture the character's dark persona.

step 1
Divide a basic sphere in half in both directions. Divide the lower half of the face roughly into thirds. Draw the features in their simplest form.

step 2
Add detail to the features and note the lines that indicate the sagging cheeks and jaw line. Shade to give shape and form to the face.

step 3
Add colour to complete the character. Flushed cheeks and a red nose give an unnaturally florid and bad-tempered appearance.

step 1
This straight-on view portrays a squat head shape based on a circle. Divide the basic shape as before and plot the position of the features.

step 2
Now develop the evil character. Focus on the twisted mouth full of nasty teeth. The eyes are deep-set and wide-spaced to lend a demented air.

step 3
Amplify the character's maniacal appearance, creating yellow teeth in the twisted mouth, and highlight the anger lines between the brows.

step 1
This grotesque face combines an old man with a toad. Sketch in the flattened oval of the head and indicate the eye, nose and mouth lines and the fat, short neck.

step 2
Now go all out for the toad features. Add detail to the bulbous eyes buried in flesh and the wide, leering mouth with its evil fangs. Add shading to the fleshy bulges.

step 3
Add a green tinge to the skin to emphasize the toady nature of this character's face. He's creepy but a bit whimsical, too.

EXAGGERATION

Concept artists in the game industry will often use exaggeration to portray alien yet disturbingly familiar features on a humanoid face.

multiple features
Multiples of eyes, ears and mouth are disturbing when placed where they shouldn't be or in abnormal numbers.

symmetry vs asymmetry
Asymmetry works well in fantasy art, but symmetry creates some bizarre characteristics too, often insectlike or robotic in nature.

elongating key details
Elongated features, like the neck and mouth of this spectral figure, will give your subject a ghostlike appearance.

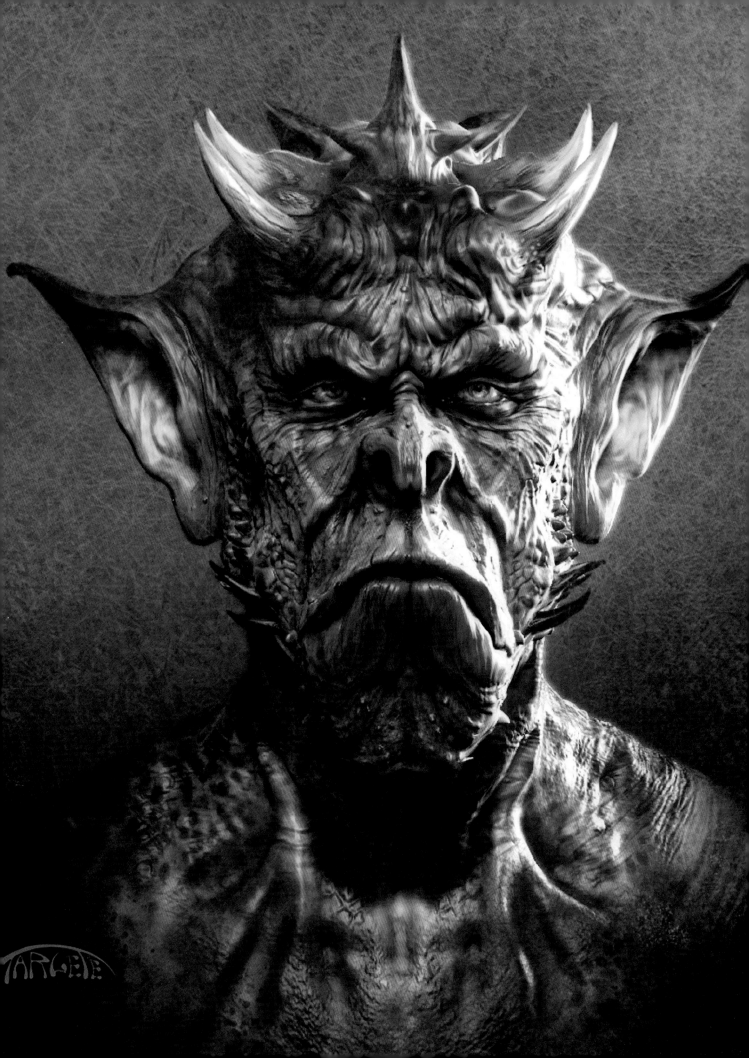

IN THE ARTIST'S STUDIO

Title of Work: *Orc Boy*

Artist: J.P. Targete

Media Used: Digital paint worked up in a sculpting software called Mudbox by Autodesk (see page 115). Many artists are using programs like ZBrush, Mudbox and 3D-Coat to create what is called 'concept sculpts', the equivalent of a 2D concept but in 3D. These show art directors a good idea of what the final piece could look like.

Techniques: I started with a default sphere and slowly built up the form by subdividing the polygons and adding more detail. Once I was happy with it, I started to paint on the sculpt. Mudbox has a decent set of painting tools; not like Photoshop, but good enough. The nice thing about the painting tools is that you can use symmetry as you paint on the model in real time. I can also paint on the different material channels like specularity, gloss and bump, to add that extra level of realism I need. Once I finished the painting, I took a screenshot of my sculpt and used Photoshop for touch-ups and added the background. The touch-ups were minor; I just cleaned up some of the edges on the silhouette, as they were blurred from the screen capture.

Golden Rule: Character Integrity

I wanted to create an atypical Orc by giving him a sombre expression, as if he had seen much hardship. The eyes and brow and mouth shapes are so important to conveying this. As humans, we convey these expressions every day and if we capture some of those expressions in a non-human character, then that character can be instilled with any emotion we want. You will give the character integrity, and the audience will relate to or understand this. Try the following:

• Practise facial expressions in front of a mirror at home. Watch how your face distorts, what muscles move, and how masses change, especially around the brow and cheeks.
• Sketch what you see. Observe the whole face for subtle movement that will add realism and think in terms of the emotion you want to express, rather than the name of the expression – there is a distinct difference between a smiling face and a face displaying happiness.
• Use emotions you've sketched when painting your next fantasy character, and he or she will come to life.

Using Mirror Images

A benefit of software manipulation of faces and body parts is the ability to create symmetry. Symmetrical faces take on bizarre characteristics, inhuman in their perfect symmetry. Here, two original artworks have been split vertically down the middle. Each side of the face has been duplicated, flipped, and the two identical halves pasted together to create two quite different characters from the same family.

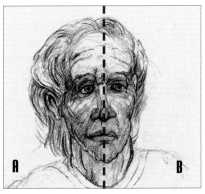

Original Artwork
First scan your image. Find the midpoint of the face and divide it in half vertically. Duplicate side A and side B. Flip the copies (A1 and B1) horizontally. Merge A and A1 and B and B1.

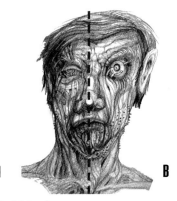

Original Artwork
Here, the original face is more disfigured and asymmetrical. Mirroring an already exaggerated face creates two very different characters, but you will find they share characteristics. Cut, flip and merge the images as described left.

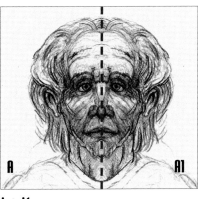

A + A1
With hair askew and a sombre expression, this face resembles a wild wizard.

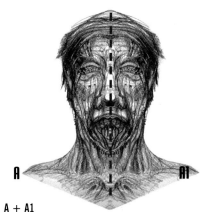

A + A1
Sides A and A1 create a triangular, rodentlike face when merged, like that of a maniac.

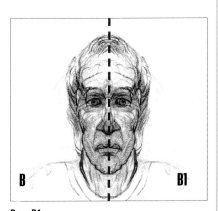

B + B1
When married, side B and B1 form an elongated face like that of a taciturn clerk.

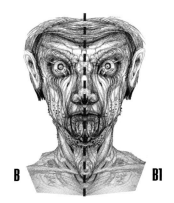

B + B1
Sides B and B1 merge to form an egg-shaped head. This creature resembles an amphibian and is perhaps a little melancholy.

IN THE ARTIST'S STUDIO

Title of Work: *Barrakus*

Artist: J.P. Targete

Media used: Pencil, ink wash, digital painting

Techniques: Clean line drawings; layered washes of brown ink on coloured paper for the monochromatic images

Golden Rule: Devil Is in the Detail

Think of a landscape. When you first see it, it is just large shapes of colour, but as you get closer you start to make out details. Adding detail in your concepts is not always necessary, but if you would like a 3D artist to faithfully capture your exact designs, then you must supply the correct level of detail. Many concept artists will leave the detailing to a trusted 3D artist; I prefer to give him or her exactly what I envision, right down to the jewel on the belt buckle.

▼ character roughs

These designs were my initial ideas put on paper. It's always important to make sure you explore your ideas, because as far-fetched as they may seem to be at the time, they could lead to a very successful design.

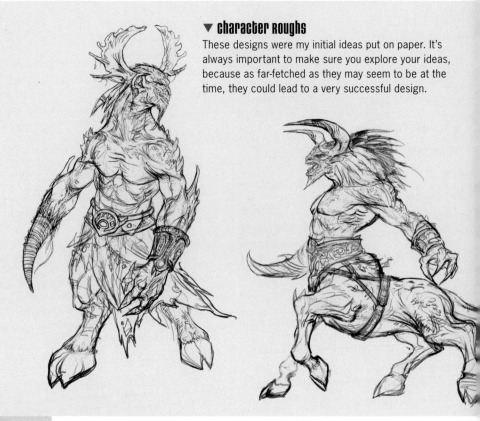

◄ clothing the figure

Along with good anatomy and creature design, costume design is an art form. This is where you give your character a history, a culture and a place in your game's world. Design to fit the character's silhouette and frame. Barrakus' defining body shape is triangular and all his costuming is designed with this in mind, from his animal-skin skirt, to his beard, to his pendant. Everything feels as if it has been tailor-made just for him. The key word is 'customization'.

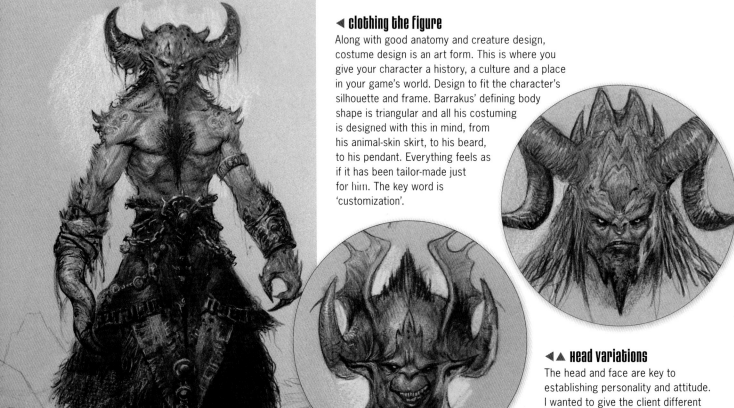

◄▲ head variations

The head and face are key to establishing personality and attitude. I wanted to give the client different head and horn variations, from sinister to playful. The key word at this stage is 'personality'.

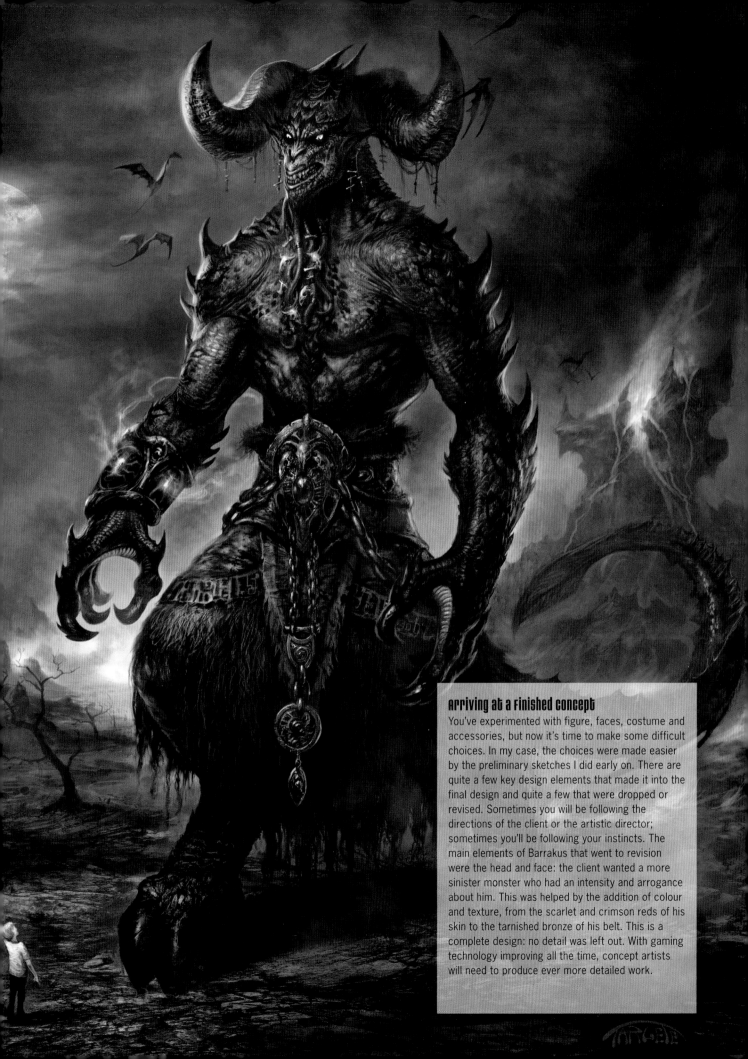

arriving at a finished concept

You've experimented with figure, faces, costume and accessories, but now it's time to make some difficult choices. In my case, the choices were made easier by the preliminary sketches I did early on. There are quite a few key design elements that made it into the final design and quite a few that were dropped or revised. Sometimes you will be following the directions of the client or the artistic director; sometimes you'll be following your instincts. The main elements of Barrakus that went to revision were the head and face: the client wanted a more sinister monster who had an intensity and arrogance about him. This was helped by the addition of colour and texture, from the scarlet and crimson reds of his skin to the tarnished bronze of his belt. This is a complete design: no detail was left out. With gaming technology improving all the time, concept artists will need to produce ever more detailed work.

compositional dynamics

In game art, you are drawing the viewer to a particular window. Each requires a different approach in composition based on the focus and mood or utility of the concept. In video game art, you are always working in a set format: the dimensions of a computer screen. This might sound very restrictive, but in fact it presents you with a variety of compositional options.

Light source as focus ▶

For centuries, artists have been using light to guide the viewer's eyes through their compositions. In this piece, the lone figure is looking upon an illuminated alien palace. As he is in awe of the scene, so we too are drawn to the light and wonders that the scene brings.

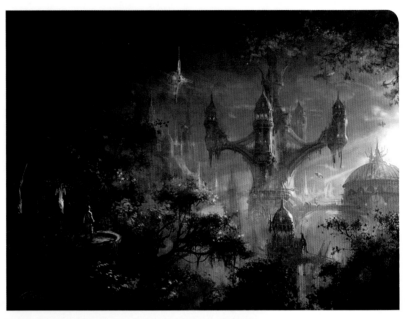

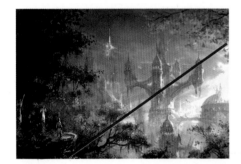

◀ centrally placed features

One of the most basic but effective compositional choices is to place your main point of interest close to the centre of the picture frame. In this piece, it is obvious that the large, dome-topped structure is our main focal point, not only in size but in placement. Although it's not exactly in the centre of the frame, its visual dominance trumps the other structures, which look frail in comparison.

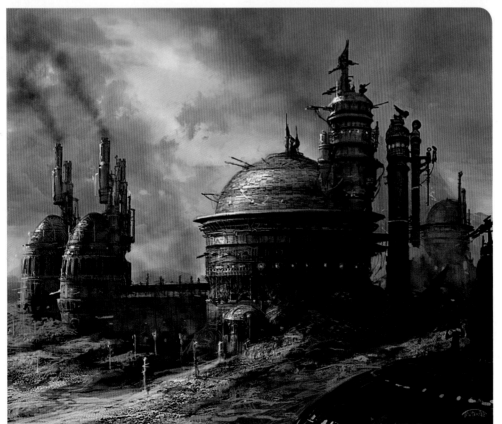

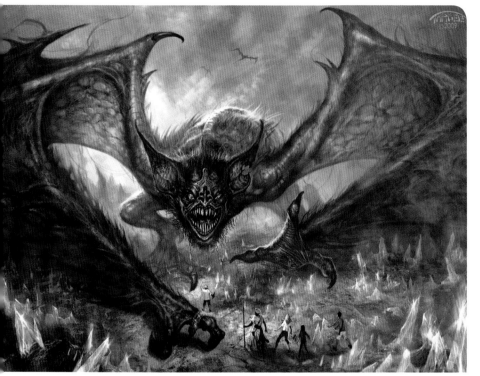

◄ Framing the Central Action

Diagonals are a strong compositional framing tool. Using the creature's wing extremeties as a subliminal framing device, the artist channels the action that is taking place in the scene, but also influences what the viewer is seeing: the composition serves both the game action and what the player sees.

Reading From Left to Right ►

The use of positive versus negative shapes has always been a powerful compositional tool. When used to lead the direction of the eye from left to right or vice versa, it can be even more powerful. In this fantasy jungle scene, the trees serve as the negative shapes, which lead your eye from the ape on the left, across the middle branch where the hero sits, and out into the castle backdrop. The artist wants you to see the focus of the piece (the castle) through the eyes of the hero and the composition has been built around this intention.

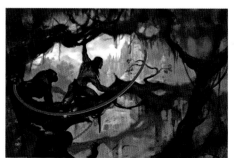

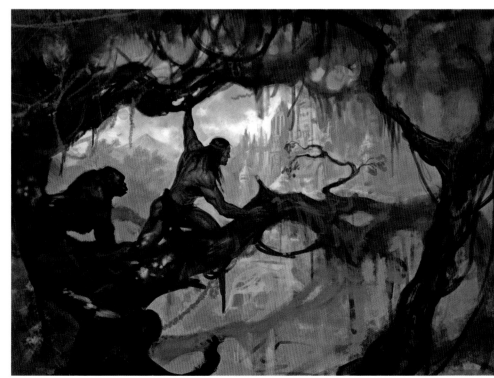

Basic principles of perspective

The classic system for creating an illusion of three-dimensional space and form on a two-dimensional surface, perspective can be used in a simple or complex way in fantasy art, but invariably increases the impact of the drawing.

Perspective is based on a horizon line, which may be observed or notional, and one or more vanishing points fixed on the horizon.

ONE-POINT PERSPECTIVE

In one-point perspective, all horizontal lines receding from the viewer go to one vanishing point. Verticals are fixed, and horizontals parallel to the horizon remain horizontal. This is the equivalent of looking straight down the street; the roadsides appear to converge on the horizon, and houses lining the street appear smaller with increasing distance. One-point perspective is by far the easiest method to use, and in terms of fantasy shorthand, it does an effective job.

TWO-POINT PERSPECTIVE

In two-point perspective, you have two vanishing points at some distance from each other on the horizon; receding horizontals go to one or the other point. This is illustrated by the idea of standing at a street corner to see down two streets at once.

THREE-POINT PERSPECTIVE

Three-point perspective enables you to emphasize distance upwards or downwards. It works similarly to two-point perspective, but verticals also converge on a vanishing point. If they converge upwards, you have what is known as the worm's eye view; imagine being at ground level in front of a corner building, able to see down two streets and up the front of the building simultaneously (this is not a normal kind of vision, as in such a situation you tend to focus on things sequentially rather than all at once). In the aerial or bird's eye view, the third vanishing point is below the building, so the walls appear to converge downwards.

TROUBLESHOOTING

There are practical problems associated with using perspective when your drawing is relatively small-scale. For example, the vanishing points in two- and three-point perspective are typically off the paper for an exterior view; if you bring them in more closely, the distortion is immense. You can use the principle broadly as a guideline, without setting up complicated arrangements to locate vanishing points halfway across your studio. The examples given here show you the basics of each order and its applications; if you are specially interested in systems of this kind, you can easily find specialized perspective manuals.

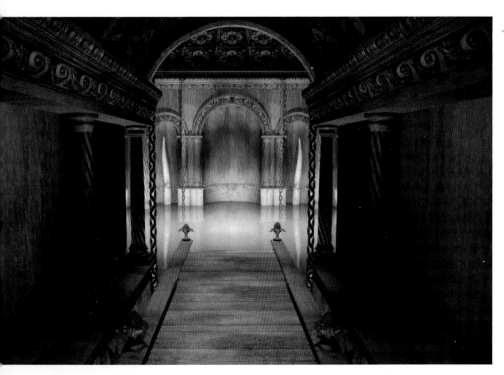

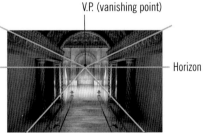

V.P. (vanishing point)

Horizon

one-point perspective

Draw a horizon line representing your eye level and fix a vanishing point on it. The further the point is to one side, the more the objects on that side are compressed. Vertical planes that face you are drawn undistorted. Lines can then be drawn back from corners and edges to the vanishing point to create the sides of a cubic shape that recedes directly away from you. The lines of the architectural frieze on the ceiling and the receding lines of the drawbridge lead the eye into the pool in the centre of the painting. The composition created is like being inside a cube that is 'angled' in one-point perspective.

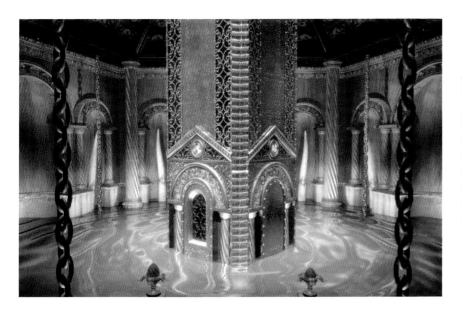

Two-point perspective

The tower in the pool is viewed in two-point perspective. There are two vanishing points outside the painting. From the vertical centre line, follow two invisible lines right and left horizontally from where the surface of the water laps around the base of the tower. Follow another two invisible lines left and right from the sides of the tower. Your vanishing points are where these two lines converge. Join up the vanishing points horizontally, and you have your horizon line.

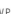

Horizon

V.P.

V.P.

V.P.

Horizon

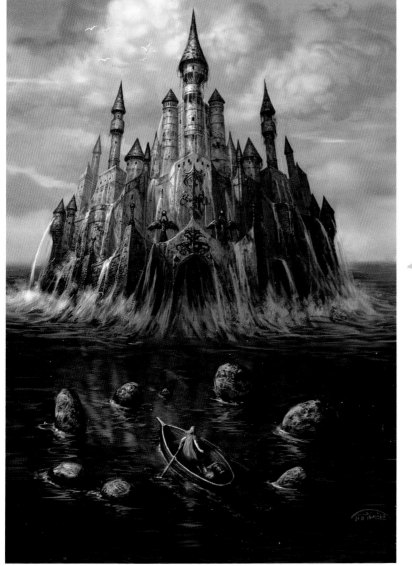

Three-point perspective

Three-point perspective creates drama in this scene, especially if, as may well be the case in a game situation, you are the diminuitive figure approaching in your boat. The vertical lines recede up to a vanishing point in the sky, while the horizontal lines recede to either side, as in the example of two-point perspective above.

Lighting Effects

The way you light your scene will convey atmosphere and create dramatic impact.

'Painting with light' is a descriptive phrase used by John Alton in his book of the same title, to describe the cinematographer's process of lighting a scene. A cinematographer is concerned with conveying mood and dramatic emphasis when lighting a shot. You want to perform a similar function with your fantasy concept's lighting, which should communicate an atmosphere and indicate the picture's emphasis.

DRAMA AND DEPTH

The amount of light in your scene will define its purpose. A dramatic scene may have only one light source, illuminating a pathway through the forest, for example, or spilling into a space from an opening high above. It may reveal a clue or necessary device.

Lighting can also create a time reference and be used for dramatic impact, such as when it blazes from an energy source like a bolt of lightning or a laser beam. Lighting provides depth cues,

too, since objects in the foreground fall into shadow, and those in the distance are lighter.

LIGHTING IN LAYERS

Applying a dark glaze in a painting, or a dark layer of colour in Photoshop, just transparent enough to allow the underlying image to show through, is like turning out the lights. Leave the objects and surfaces you wish to be illuminated unlayered and you effectively light them. This effect can be quite dramatic when a small area is

TIME OF DAY

Time of day in the fantasy game environment has both an aesthetic function and a game-mechanic function. For the concept artist, showing similar scenes in states of change presents the dynamics of an active world where light plays a revealing and deceptive role. Illustrated here is a concept for a level where stealth would get results and the time of day would aid or hinder your quest.

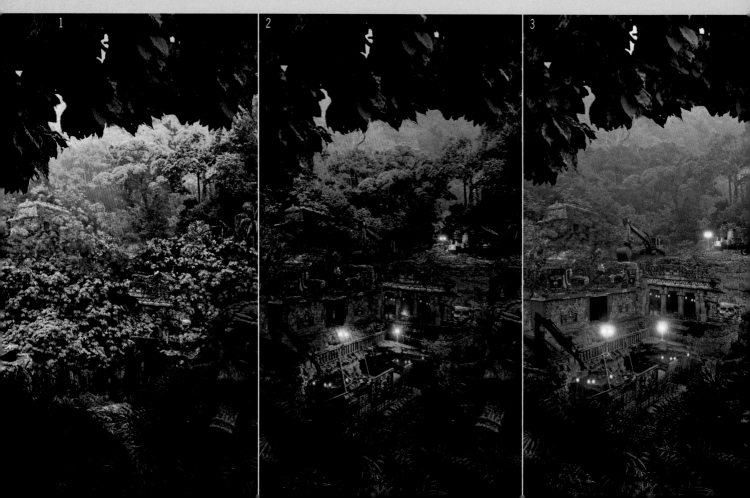

exposed, or a good method for showing light from a window in a darkened room, or from a torch on the wall, or a candle on a table.

Achieving dramatic or atmospheric effects with light usually means planning the layers. The lightest and brightest areas are the points of illumination. From a radius centred on the light spot or source of illumination the colour values move from warm to cool and light to dark as you work out to the edge of the illumination.

1. midday

The unexcavated jungle temple site is shown here in late morning light. You may be the first to see this site, but your adversaries will soon arrive, and exploration will reveal overgrown entrances in need of excavation. In Photoshop, layers of soft yellows form the neutral overcast lighting. Highlights were then overlaid to create a hazy opacity. A darker foreground of leafy canopy and ferns help to frame the composition and establish POV.

2. Night

The sunlight layers and foliage are easily removed in Photoshop and new layers added to transform a sunny unexcavated site into a major dig with night-time activity. By night, the entrances are more obvious. They offer choices; some beneficial, some not. The campfires are an indication of activity and civilization, which may be comforting to you. But who is tending to the fire? A Gaussian blur creates a fuzzy glare (see page 45).

3. dawn

In the early morning light, with the fires extinguished, a good opportunity arises. With almost everyone asleep, now is the time to search for the right entrance using stealth. Begin with a neutral-lit background image in Photoshop, and select masks that allow shadow and light areas to be added or subtracted in their own layers. These layers can then be duplicated or partially erased where light spills onto surfaces.

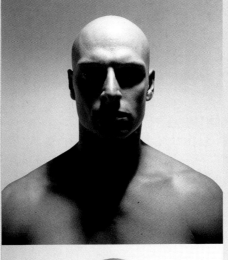

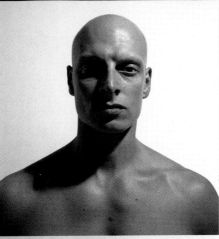

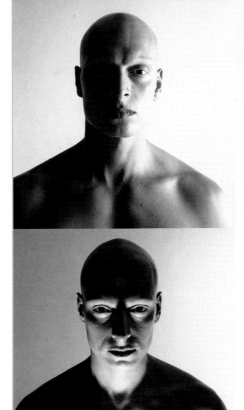

LIGHTING YOUR CHARACTERS

The way light falls across a face can determine the way you perceive personality and expression.

from Above
The eyes are completely blacked out, and his bald head and heavy brow take on an evil aspect.

from front Right
The left side of his face is in shadow, but the effect is less stark than in the previous picture.

from Right
The right side of his face and body receives fine attention to detail in the form of white highlights.

uplighting
The brow and lower lids are emphasized and the muscles on his chest and arms are thrown into sharp relief, giving a sense of sinister strength.

1

COMPARING LIGHT SOURCES

In the realm of fantasy video games, lights have numerous manifestations and uses, from personal light sources carried by the player's avatar to FX displays of magic with interactive properties. Lights of different properties will affect the scene differently, perhaps setting a mood, illuminating a critical pathway or revealing a key element. The examples shown here were made using a combination of selection masks, gradient fill and layers of brushwork in Photoshop. The Gaussian Blur filter is a useful application. Used at a 24 per cent fill, it creates a blanket glow, as in image 1.

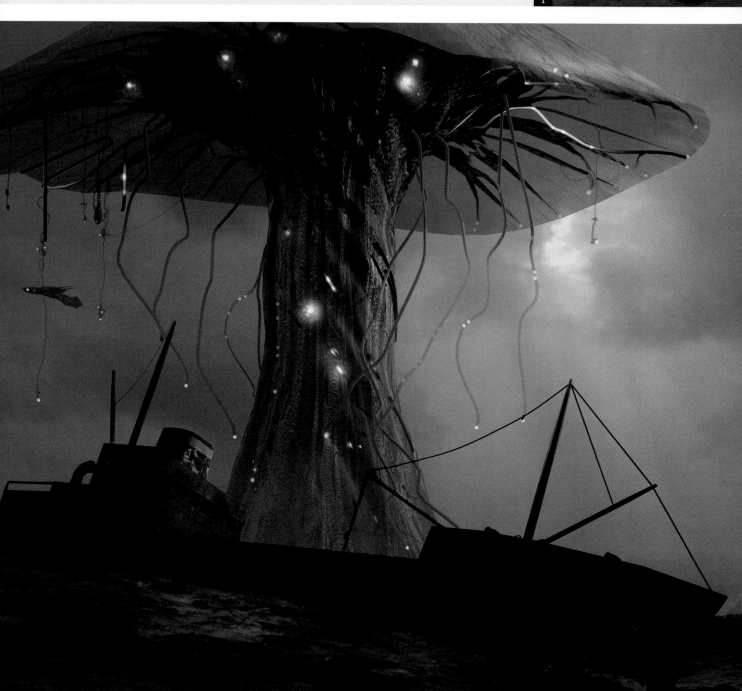

1. Flash Light
The flash light's white light illuminates what lies in its path and casts all else in darkness.

2. Torch Light
The torch light is a subtler light, illuminating only the water and wet stone surfaces. This lighting is warmer close up, and its effect is less even.

3. Electric Light
The electric light's even colour makes a uniform glow across the surfaces, and casts more ambient light than the torch or flash light.

IN THE ARTIST'S STUDIO

Title of Work: *Extinction: The Last Chapter*

Artist: Bill Stoneham

Media Used: Digital painting in Photoshop

Techniques: The 'Gaussian Blur' is a filter used for blurring a layer in Photoshop where a specific lighting effect, like the fuzzy glow in this piece, is needed. Here, all the points of light (the flares from the giant mushroom and the sun creeping through the clouds) exist on two layers in Photoshop. The second layer is a copy of the first, with the opacity adjusted to allow the source to show through, thus creating a 'Gaussian Blur' effect.

Golden Rule: Contrast
Always use a neutral or cool colour as a canvas for featuring your lighting effects, as it will create greater dramatic contrasts.

In a monochromatic tonal study of the scene, the lightest areas indicate the warmer values and the darker areas the coolest.

colour and mood

Used in conjunction with lighting, colour is an essential element in creating atmosphere, literally and metaphorically.

We associate colour with mood and physical states, so in our paintings we can use it to set a character's disposition, for example, by using dark earth tones and blue-greys for villains' garments, and light, warm tones on heroes. The colour of a scene can also convey an atmosphere. Picture a cool, blue-and-green oasis, set against bright yellow-white dunes. It's refreshing. However, paint the same scene at night, with colour and contrast removed, and the oasis and dunes become menacing. Colour can be used to express time as well, for example, by using umbers and pinks to deep purples at twilight, and pale blues and greys in moonlight. Contrasts in colour evoke drama and energy, such as when the blasts of light and colour from an exploding ship contrast with the deep blacks and blue-greens of the waves.

COLOUR LAYERING

To achieve colour's maximum effect, begin with grey values, and gradually introduce colour to the scene. Applying different layers of colour over the same scene or character will give you a sense of what colour can do for the mood of the character and the worlds he and his adversaries occupy. Layer an underpainting of light, warm values with umbers and blues, and you give it a sombre mood. The same applies to layers of colour in Photoshop.

THE COLOUR WHEEL

The relationship between colours is shown using a colour wheel. Red, yellow and blue are the primary colours (marked 'P'). When two of these pigments are mixed together, they produce a secondary colour (marked 'S'). So, red and yellow make orange, red and blue make purple, and blue and yellow make green. Tertiary colours (marked 'T') are created by mixing varying amounts of any two primary hues.

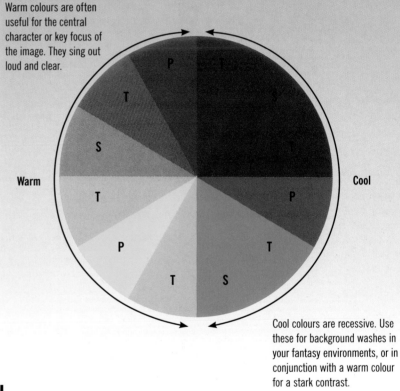

Warm colours are often useful for the central character or key focus of the image. They sing out loud and clear.

Warm

Cool

Cool colours are recessive. Use these for background washes in your fantasy environments, or in conjunction with a warm colour for a stark contrast.

MIXING COLOURS FROM THE COLOUR WHEEL

Complementary colours lie opposite each other on the colour wheel. They enhance each other's brightness and create a dynamic effect when used adjacent to each other. Analogous (or harmonious) colours lie next to each other on the colour wheel. Used together, they create partnerships with none of the pulsating vibrancy of paired complementaries. On the contrary, harmonious colours create a calming effect.

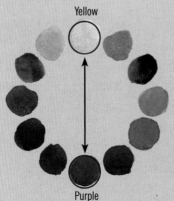

Yellow

Purple

◄ complementary colours

Yellow and purple are complementary colours because they sit opposite each other on the colour wheel; yellow always sings out loud when purple is near, and the same can be said for red and green and blue and orange.

analogous colours ►

Placed together, yellow, yellow-orange and orange appear more muted without their complementaries. So do turquoise, green and blue, which are also analogous.

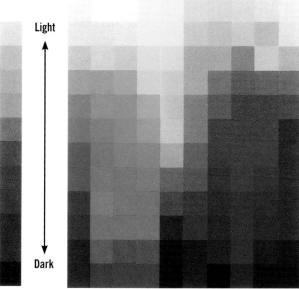

Light

Dark

◄ Tonal contrasts

This shows the breakdown of the tonal variation applied to different colours. Clearly, each gradation of a single colour provides different tones – a green, for example, can be dark and mossy or bright lime-citrus, or a blue can be qualified as midnight, sky or pale. You can make colour harmonies between colours of similar tonal quality and saturation. A series of design handbooks is devoted to listing such combinations, which you may find interesting when creating your fantasy art. Or, alternatively, look to the natural world for these subtle tonal variations.

Colour as focus ►

The key to many designs, be they for environments or characters, is to add accent colours sparingly but effectively. In this piece, it is the warm primary colours (red and yellow) that jump out at you. This is because primary colours are pure and saturated. They have a strong impact even when used in moderation, and this is often when they're used best, to pick out crucial detail in a largely monochromatic painting like this one. When painting, try not to use just lighter or darker values of the same colour to make your highlights and shadows. The real world has millions upon millions of colours that reflect and blend with each other. In video games especially, the need to differentiate certain characters from each other and their environments is vitally important.

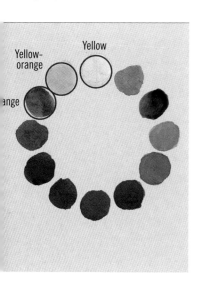

Yellow-orange
Yellow
ange

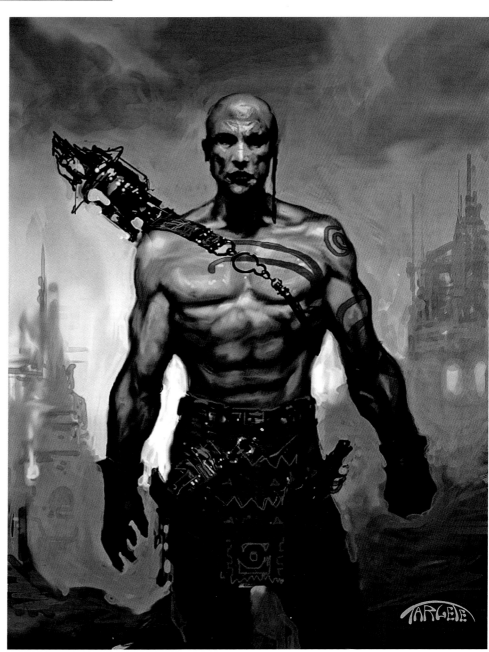

USING COLOUR TO SUGGEST TIME OF DAY

These colour studies from Sony Online Entertainment's *FreeRealms* show the colour palette planning that was done in advance of creating the 3D environment. Lighting affects the mood of a scene dramatically, so these studies were created as guidelines to aid the artists in conveying the appropriate mood using colour and light. Artists building this scene in 3D could refer back to these images to make sure they were on the right track.

Morning

Bathed in a warm morning light, the water takes on a green tone. There is a marked contrast between the sky and the mountain horizon. Adding yellow influences to the object textures unifies the colour palette, which is yellow too.

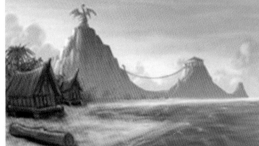
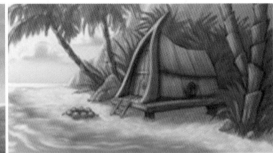

Midday

Midday is the native colour of all the game assets. The in-game light is colourless, so the full range of colour variance is on display. Warm-coloured buildings were chosen to blend in with the beach and provide contrast against the cooler green trees.

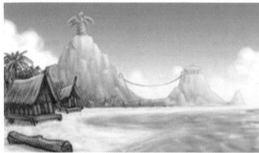
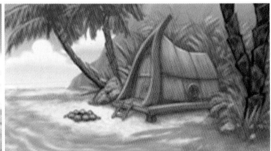

Dusk

Shadows are darker and more noticeable in this dusk scene. The water is darker in tone and the scene's colours are deeper. Later, red will be added to the in-game light – since it is the opposite colour of green, it will make the green fronds more neutral in colour.

Night

Cool neutral colours dominate the scene; there is little contrast between the sky and the mountain range. The in-game light will be cool purple, the opposite of the yellow of the huts and sand. A small campfire and window lights provide a warm touch.

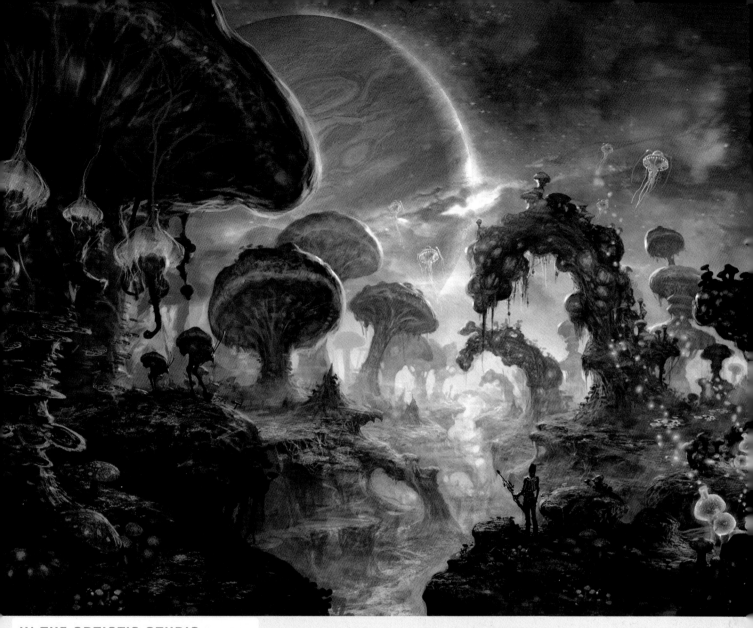

IN THE ARTIST'S STUDIO

Title of Work: *Borisia 5*

Artist: J.P. Targete

Media Used: For this piece, I sketched out a quick pencil layout of my composition, scanned the image, and used Photoshop to paint the images.

Techniques: I used Photoshop's excellent layering system to create layers of depth within the painting. By cloning and pasting layers and changing the opacity of the gigantic mushroom shapes, I was able to save a lot of time. Having to repaint each mushroom from scratch would have been tedious. I also used colour layering to achieve different levels of saturation in certain areas. In oil painting, this is called 'glazing'.

Golden Rule: Signature Palettes

Creating or deciding on a palette can be difficult. There are two questions you need to answer: 'What time of day is it?' and 'What's the climate?' If you can answer these questions, then you can begin to compile a set of colours to use. There's a distinct difference between sundown in the middle of winter and noon on a summer day. Another technique is to look at reference materials like photographs or master artworks for inspiration. You can take a few more liberties when creating a palette for an alien world, but try to be coherent and make your colours work with each other. It takes practice to get it just the way you want it.

Looking at your painting in black and white as you build up the colour layers will help you to apply a wide tonal range; in this case, the colour purple is represented in all its variants, from deep blue to light pink. A wide tonal range will ensure your work does not look flat. Highlights add drama and lead the viewer's eye into and around the piece.

creating a believable fantasy world

As digital technology has achieved higher resolution and rendering capabilities, artists have focused on realism, delivering – within the fantasy realm – believable environments and creatures using the latest texture mapping and modelling techniques. Over the next eight pages, you will observe how an artist has responded to four different sample briefs, creating convincing game assets for an engaging game environment.

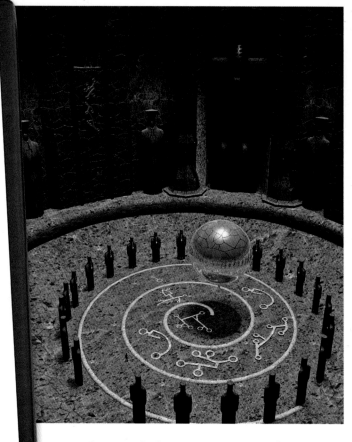

Brief 1: THE CLOCK OF THE DESTROYER

Set on the volcanic continent of Zar, there are eight levels of fiery, cavernous fortresses and temples in this first-person shooter game, where you will encounter traps and enemies as well as rewards to aid your quest. You are on a mission to stop the Destroyer of Worlds.

Environment: Your immediate surroundings are the remnants of an ancient and powerful civilization that, over the centuries, has harnessed the magma from the planet's core. The environmental concepts should be created with cinematic cut scenes and occasional non-interactive scenes showing your avatar in action.

Character: Enigmatic masked figures, draped in ornate glyph-inscribed robes are the servants of the Destroyer, your arch-enemy. They are able to protect themselves by hardening into stone. Only the right weapons will harm them, weapons you will have to earn through each level of challenges.

▲ the great clock room

The Great Clock Room of the Destroyer might look like this: a statically suspended sphere tapered into a point at the bottom traverses the room, its rhythm set to the galactic rotation. Each statue it knocks over represents a 10,000-year cycle; when the last falls so falls the Empire of Zar. The last statue is days away from being hit and the designer is held prisoner in the temple of fire: your task is to free him.

WEAPON VARIATIONS

All the weapons in this fiery world are in keeping with the theme, to ensure successful combat but also to create verisimilitude according to the creative vision.

◄ The master weapon for the elite warriors, the fire sword's flaming core cuts metal like butter and will cauterize living flesh as it slices.

◄ The fire sling is carried by ground troops, who use them to fling wave after wave of molten marbles the size of hens' eggs.

◄ The fire spear, hurled by flying cavalry, rains destruction on armies and buildings, melting armour and flesh.

▲ The magma gun is carried by shock troops, whose function it is to destroy enemy command and control centres, and their officers. The gun fires molten pellets at Mach 1 velocities.

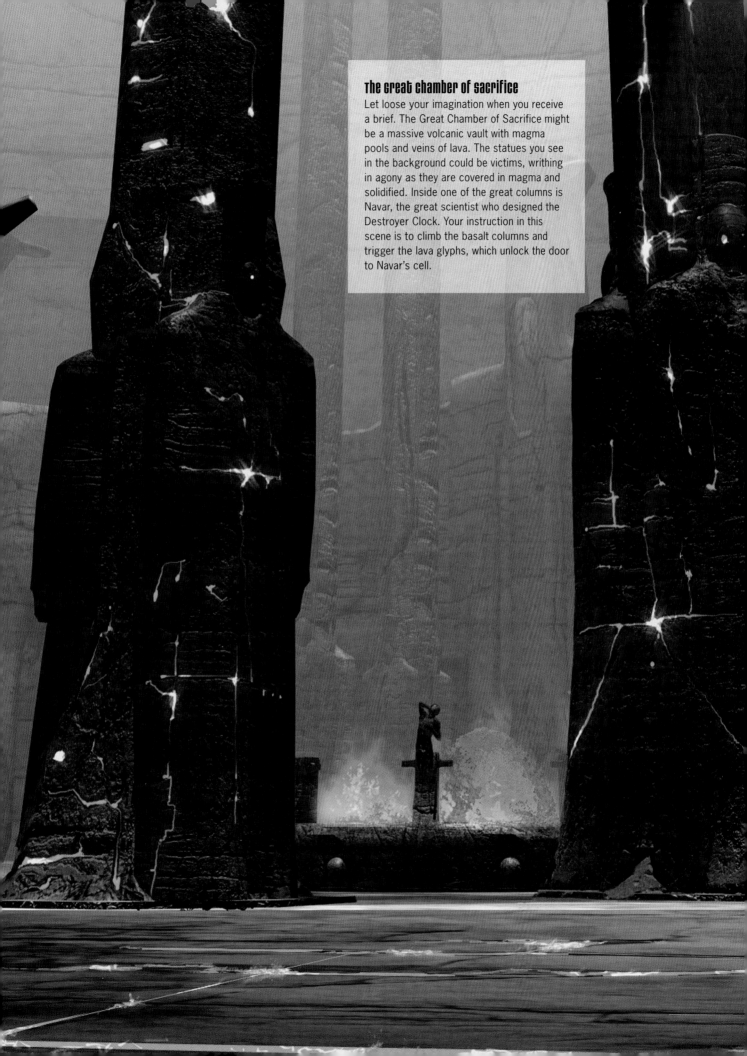

The Great Chamber of Sacrifice

Let loose your imagination when you receive a brief. The Great Chamber of Sacrifice might be a massive volcanic vault with magma pools and veins of lava. The statues you see in the background could be victims, writhing in agony as they are covered in magma and solidified. Inside one of the great columns is Navar, the great scientist who designed the Destroyer Clock. Your instruction in this scene is to climb the basalt columns and trigger the lava glyphs, which unlock the door to Navar's cell.

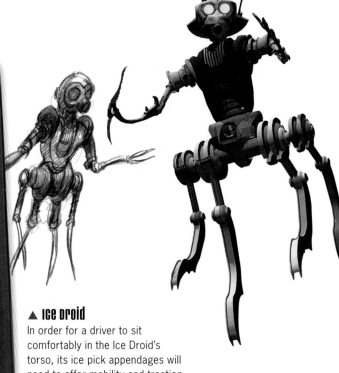

BRIEF 2: THE FROZEN REALM

This strategy role-playing game is about survival and gathering artefacts, re-activating abandoned weapons, battling adversaries and forming alliances.

Environment: For a fantasy artist it presents the challenge of ice and snow as the dominant elements. There are five levels of exploration through ice and rock towers, and caverns to master, the most difficult being the underwater level containing sunken vessels of an alien civilization. Your skill and the alliances you make along the way will help you in your exploration and discovery of hidden caches of power and knowledge – and your ultimate battle with the Ice Queen.

Characters: There are several characters in this world: the Ice Droid, a six-limbed smart armour from an older civilization (the driver sits in the pelvic compartment); the ocean dwellers, some predatory, some friendly; the Horned Mudwort, a bottom-feeding marine mammal with a pair of tusks growing from its head crest that can break through the ice or uproot urchins and shellfish – or defend against the Marasaur, its only predator.

▲ Ice Droid

In order for a driver to sit comfortably in the Ice Droid's torso, its ice pick appendages will need to offer mobility and traction over ice walls, and its armoured head will need to carry deadly firepower. In this design, an 8-cm (3-in) cannon is buried in its head and clawing extensions make up its arms.

◄ Wind Sucker

Spawned in the ocean, the Wind Sucker is an airborne jellyfish that produces a hydrogen gas and floats into the seasonal winds that blow across the ice, grasping anything it encounters and enveloping it with paralyzing tendrils.

Traversing the Ice Barrier

The concept painting that was developed in response to the brief above shows half-buried structures that hold keys to the underwater level. Your task is to unbury the ice axe that will aide you in traversing the ice barrier wall to where the ice and stone fortress lies. The channel between the stone columns and the fortress is treacherous with thin ice and marine predators ready to burst through and devour the careless. An alliance with a Horned Mudwort will get you across safely.

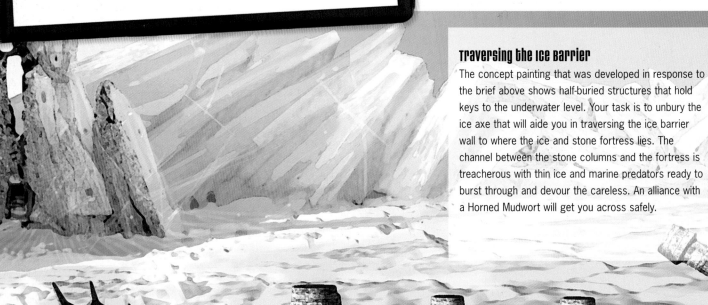

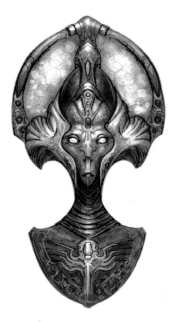

▲▶ The ice queen

Your final fight is with the Ice Queen – if you've been lucky enough to survive the Marasaur and Ice Smashers. The deep purples used in this design are in keeping with the frozen realm, but they're also royal colours that elevate the Ice Queen's status above that of any other in the game, including you.

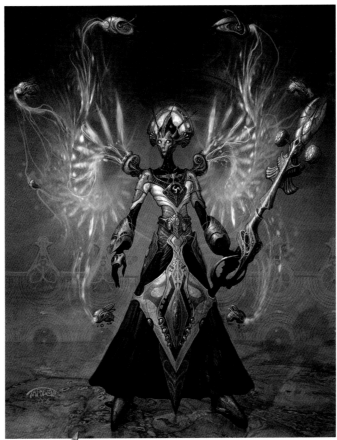

◀ marasaur

In this artist's design, the Marasaur is depicted as a sharklike predator whose main diet is the Horned Mudwort, although it will eat anything in its territory. This creature is the main game of the Ice Smasher, which hunts it over the ice, then smashes the ice above and slashes its spinal cord with its axe.

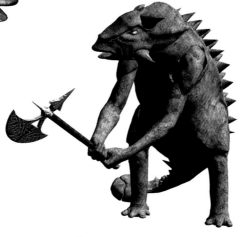

▲ horned mudwort

If the two main motivations of the Horned Mudwort are food and self-defence, the character design must reflect this. The two tusks growing from its head crest are both practical and striking.

▲ ice smasher

The Ice Smasher might be an armoured cave dweller, with a thick horned hide and a clubbed tail that it uses defensively, or to smash the ice above feeding Marasaurs. This character might team up with Mudworts to trap Marasaurs, as they're from the same family.

WEAPONS AND PROPS

In order to meet the challenges of ice, most of the weapons in this world are pike and axe variations.

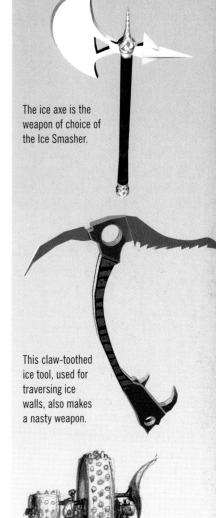

The ice axe is the weapon of choice of the Ice Smasher.

This claw-toothed ice tool, used for traversing ice walls, also makes a nasty weapon.

The Giant Snow Wheeler's gyroscopic motor keeps it level. The driver rides on the axle cockpit, another bit of ancient technology left in the deep-freeze.

BRIEF 3: THE CTENOPHORE

An action–adventure game where the player uses learned abilities to overcome challenges.

Environment: A vast water-covered planet. You are one of many nomadic seafarers who must trade with the ocean-dwelling species and avoid the city-sized Ctenophores that drift above the water and sink onto coral reefs to form colonies. There are eight levels of challenge from the water surface. Find your way to the secret chamber in the heart of the oldest coral citadel and retrieve the lost book of the Ctenophoric Spells, and you'll bend the giants to your wishes.

Characters: The planet's dominant life forms are the city-sized Ctenophores. When the Ctenophores age, they anchor permanently, lose their sting, and so become home to several species, including the Horned Krakenoid, a bizarre creature with a lower body of tentacles and a furry human torso, sharp face and two ram's horns atop its head like ammonites. It dwells in the tangled coral roots of the giant Ctenophore towers where it hunts the huge Temple Krabs with shell-smashing axes. The Temple Krabs, named for their coral habitats, represent the main population of the coral tower, where they carve out elaborate interior chambers with their acidic saliva and adapted claws. The smallest population group is you, the nomadic humans.

▶ Baby ctenophore

The Ctenophore's larval phase starts in the world's upper atmosphere, in the towering clouds of nutrient-rich moisture where the Zeppelin-sized larvae feed. The nutrients might, for example, contribute to tendril growth, so in this quick sketch of a young Ctenophore, the tendrils are sparse. It's only later that it grows so big that the Ctenophore sinks towards the water to feed on your boat.

▼ young Krakenoid

Think about how a character might evolve throughout the game time. In this design, the juvenile Krakenoid lacks two additional tentacles and thick torso fur.

▲ Adult Krakenoid

The adult male Krakenoid, on the other hand, brandishes a krab-killing axe. It can survive out of the water for up to a month, hunting Temple Krabs in the interiors of the Ctenophore towers. Think about how a female Krakenoid might differ from the male.

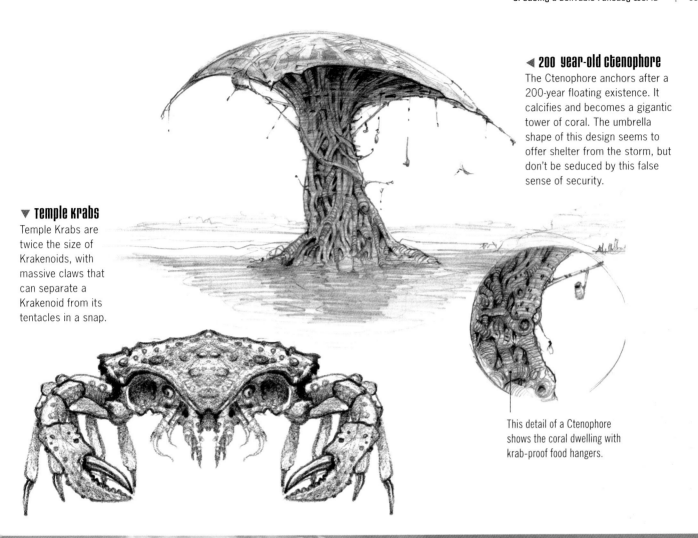

◀ 200 year-old ctenophore

The Ctenophore anchors after a 200-year floating existence. It calcifies and becomes a gigantic tower of coral. The umbrella shape of this design seems to offer shelter from the storm, but don't be seduced by this false sense of security.

▼ Temple Krabs

Temple Krabs are twice the size of Krakenoids, with massive claws that can separate a Krakenoid from its tentacles in a snap.

This detail of a Ctenophore shows the coral dwelling with krab-proof food hangers.

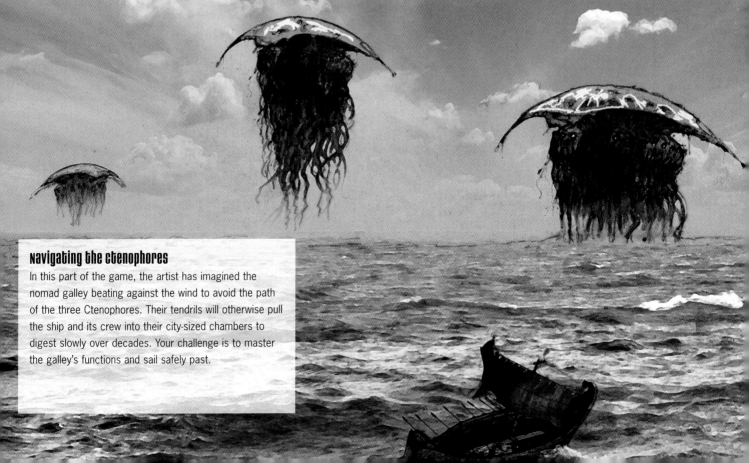

Navigating the ctenophores

In this part of the game, the artist has imagined the nomad galley beating against the wind to avoid the path of the three Ctenophores. Their tendrils will otherwise pull the ship and its crew into their city-sized chambers to digest slowly over decades. Your challenge is to master the galley's functions and sail safely past.

BRIEF 4: GODDESS OF ANNIHILATION

Venomous reptiles, bloodsucking bats with 3-m (10-ft) wingspans, and the ruins of a cannibalistic civilization entrap and kill the uninitiated in this action game. The player will need every survival skill to uncover the hidden devices and chambers in his search for treasure.

Environment: The setting is a planet of jungles and steaming volcanic ash. Nine levels of challenges lead to the final goal: the golden statue of the Goddess of Annihilation, hidden away in the volcanic temple. Danger is everywhere.

Characters: Whatever human population built the temples and structures in the jungles has long since vanished. Only their 'offspring' remain. Genetic monstrosities like the huge Vampire Bat, capable of draining a human of all its blood in a single feeding, or the twin-tailed Quetzal Serpent that guards the sacred pool, with jaws large enough to swallow a horse.

▼ Hydranoid

The Hydranoids have venomous heads and are armed with razor-sharp knives.

▶ The Sacred Pool

The concept artist will work with the level designer to plan out the areas of interactivity in the game environment. In this design, the artist has pitched the entrance to the Sacred Pool beneath the Quetzal Serpent and the statue puzzles (right). The distant volcano smoulders; a reminder that in its deepest caverns lies the great statue of gold that you seek. Vampire bats begin their twilight feeding, catching unwary prey. To attain the great statue, you must first solve the riddle of the Sacred Pool. The riddle will grant you entrance to the deep cave entrance shaft leading to the volcano's temple.

EARTH OBJECTS

The emphasis in this game is on physical skills and combat abilities, but also mental aptitude. This statue contains riddles that are key to your success in the game.

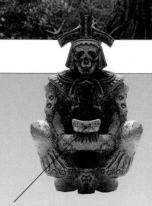

This grim god of flesh and bone provides the key to unlocking the underwater chamber within the Sacred Pool. From the front, you can see the sacrificial platform, where victims are bound.

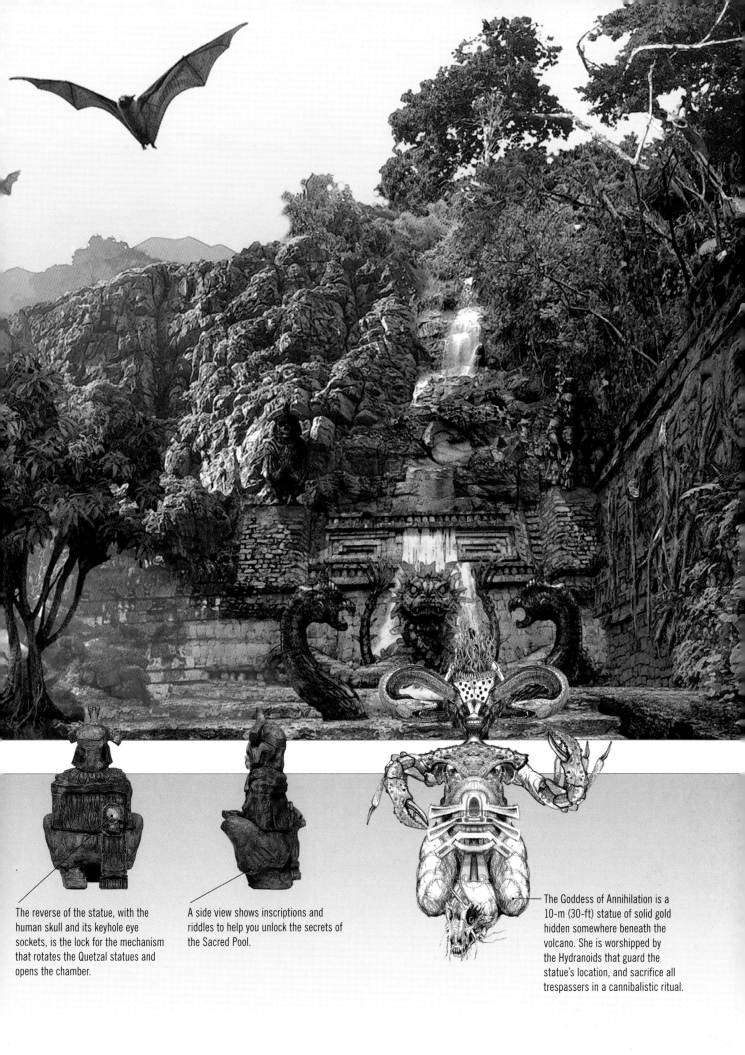

The reverse of the statue, with the human skull and its keyhole eye sockets, is the lock for the mechanism that rotates the Quetzal statues and opens the chamber.

A side view shows inscriptions and riddles to help you unlock the secrets of the Sacred Pool.

The Goddess of Annihilation is a 10-m (30-ft) statue of solid gold hidden somewhere beneath the volcano. She is worshipped by the Hydranoids that guard the statue's location, and sacrifice all trespassers in a cannibalistic ritual.

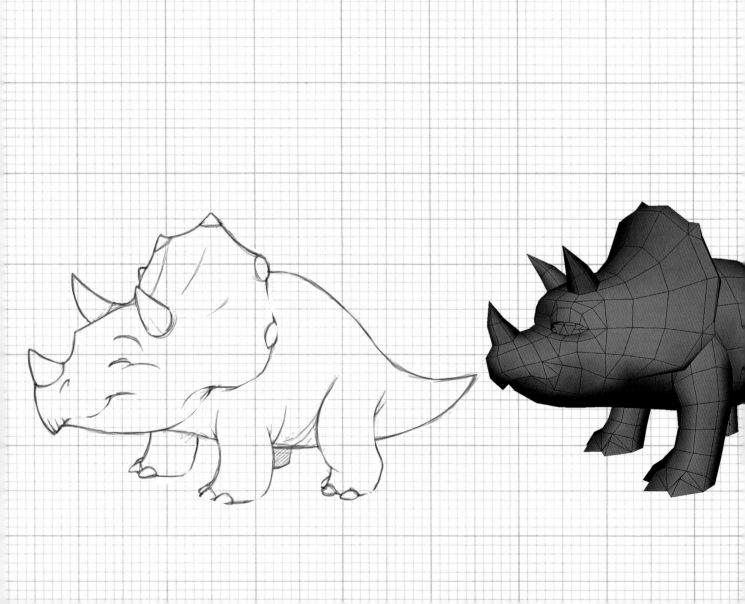

02 MOVING BEYOND 2D CONCEPT ART

when your concepts are approved, your art will be the driving reference and inspiration for a skilled group of modellers and animators. they'll use 3D modelling software to create environments and creatures to populate them, all based on your drawings. the techniques and stages for modelling and texturing will vary from company to company, but these pages will give you an overview of the key processes.

Level Design

The term 'level design' refers to individually designed sections of a game. It happens after the main concept has been fleshed out and the game mechanics have been identified.

Video games can be broken into smaller sections, or levels, just as books and films are broken into chapters or scenes. The level designer will provide a block mesh from the world builder or environmental artist as an underlying guide for your game-play concept. Your task is to layer over the block mesh with artwork, providing the environmental artists and level designers with interactive areas and path limitations that are well matched to the artistic conceits of the genre.

IMPORTANT CONSIDERATIONS

When designing game levels there are factors to consider. If you are working on an established intellectual property there are likely to be additional guidelines.

■ **Reward:** When a player tackles an enterprise, subconsciously he expects a reward. This can take the form of an increased skill-level, an in-game item, a discovered secret or simply the satisfaction of a challenging task completed successfully.

Drawing up a cross-section

Drawing up a cross-section of the level designer's block mesh is a good place to start. Ideally, the modeller is provided with concepts before creating the mesh. Now is the opportunity to work out the final look. Think about what the environment might look like, what the temperature is, what textures there might be. This will give you an overview of the complete game environment, and from here you can begin to imagine where the challenges, risks and rewards might be, and where the paths might lead.

The level designer's mesh rendering.

Step 1

The mesh rendering is sketched over to provide some texture for layering and blending. Here, details of rock are added, emphasizing the contours and crevasses.

Step 2

Build up the layers in Photoshop. Here, a green filter is applied at 39 percent and saved on a separate layer. Another layer, containing the shadows, is applied at 45 percent.

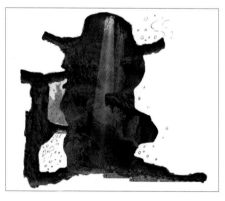

Step 3

Add the details. Create a new layer and use the Polygonal Lasso tool to shape the shaft of light. Use the gradient filling (foreground to transparent) with off-white for a spectral appearance. Cut and paste from images of textured rocks to build up the ledges.

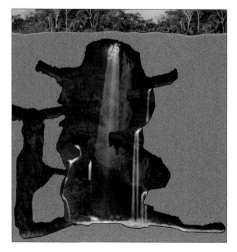

Step 4

Waterfalls and streams are added for challenge and atmosphere.

- **Risk:** The reward should match the risk. If the player has made the pixel-perfect jump over a robo-piranha-infested lava lake, then reward him with something worthwhile or he may feel that the game is gratuitously challenging.
- **The pace of challenge:** Players appreciate the opportunity to start with an easy challenge in order to practise and learn. After this, they can more readily accept an increased challenge.
- **Interest:** This concerns maintaining a player's engagement with the game. A game can only have so many game mechanics, and will only have a limited number of opponents or challenges.

Hidden Levels of Interaction

The player will need to interact: find clues and rewards, confront danger lurking in the dark and take the right path. You need to tell a story with your environments and plot them on the block mesh. Options enrich the game narrative. Here are some ideas.

▲ This is the entrance to the cavern. Easier challenges should be placed here as it is likely to be the first of many levels. Use the same game mechanics that will be required deeper in the level; it lets the player become familiar with the game play required with minimal risk.

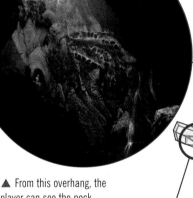

▲ From this overhang, the player can see the pock-marked surface offering hand- and foot-holds and alcoves with valuable objects. Dramatic lighting illuminates potential pathways and adds danger.

▲ A spider's lair is illuminated. Focusing a beam of light on an entrance is a good visual indicator to the player to proceed. The extra visual attention signals that he needs to eventually find the method to get there, however dangerous.

◀ Discovering evidence of past expeditions will heighten the feeling of danger and make the player feel heroic. He has succeeded where others have failed. The bones act as a warning that the player may be the next meal and that a creature is on the prowl.

◀ Players expect better rewards the deeper they progress. The toughest creature in the zone lives here (referred to as a 'boss' monster, because defeating it usually means you've completed a significant stage of game play for the zone).

digital modelling

Your design is complete, it has been approved by the artistic director, and you've prepared a clean and accurate working illustration from which the model will be built. So, what next?

CREATING YOUR OWN DIGITAL MODEL

Industry software is expensive and not usually something the concept artist needs access to. While the digital modeller is responsible for your character's 3D life, not you, there are some affordable software programs, such as Autodesk 3ds Max (see page 115), that will give you an insight into this fascinating transformation.

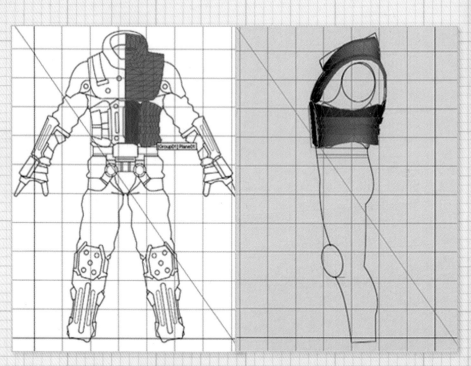

STEP 1: Two Planes ▶

Two planes are created at right angles and the images are placed onto these as textures. They are correctly proportioned to the character. Using these references, the modeller can now begin to build the model over the images. By looking directly from the front or the side, the modeller can see the profile straight on and begin to create geometry to match.

Bulk of body
First, the body is built from individual polygons; the bulk of the body is defined.

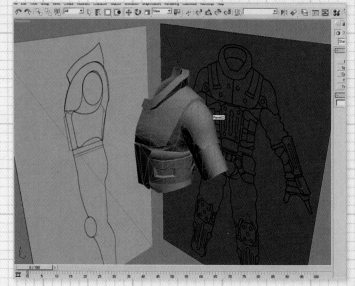

▲ STEP 2: Moving Vertices

The modeller first looks at the front of the model and then the side in order to develop form. This method begins with flat planes to build the model. Other methods start with a cube or cylinder and extrude faces from those. The principle in both methods is the same, which is moving vertices to align with the illustration reference. This part of building the model is quite painstaking, and the modeller will have to continue to switch between views and keep checking if the model he is building is accurate. The modeller continues in this manner until he is satisfied.

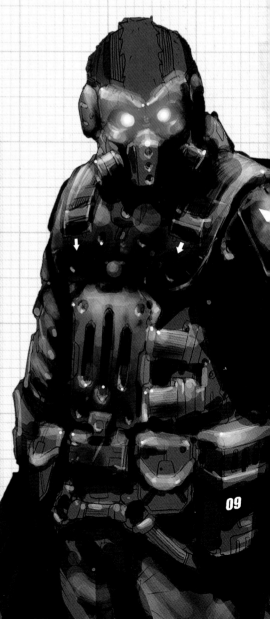

▲ STEP 3: Building Half a Model

It is interesting to note that only half the model is built in this fashion; this is because, if the character is human, it is also symmetrical. When half of the character is built, the modeller can simply mirror it within the modelling program and the other half will appear. Working in this way also makes sure that no discrepancies sneak into either side of the model to make it look lopsided.

Polygon check
Viewing the edges of the polygons allows the modeller to check the geometry is 'clean'.

Building the body
Half the body is built, then copied, flipped, and attached to the first half to build a complete body.

What about the head?
The model is designed to have several head options to increase the number of characters without making a new body mesh for each one. The heads will be modelled at a higher level of detail.

Static model
The body is complete but it is still a static block and has not been 'rigged' yet.

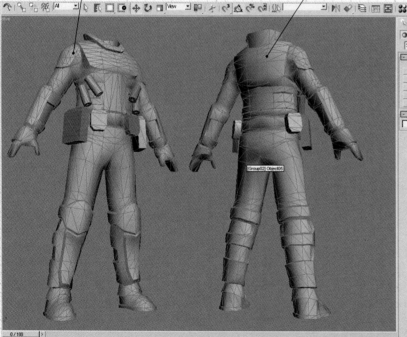

▲ STEP 4: Body Model

The model of the body is built. Because this is a central character in the game, and will be seen a lot by the player, it has a relatively high polygon budget, and that means it can be a more complex model. This gives the modeller the opportunity to model the head separately and pay particular attention to getting the form of the mesh right.

Final concept design
You will have generated many sketches and drafts of the character in differerent styles before the design team decides it has the right one.

09

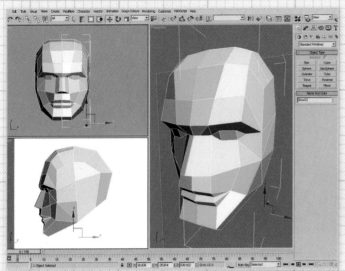

▲ STEP 5: Building a Head

Using a different technique from that used to construct the body, the modeller first builds a dummy head to the correct scale (this will be deleted later). This is used as reference for the helmet. The modeller builds half the helmet and spends time making sure that the artist's original vision is maintained.

▲ STEP 6: Neck Check

The head is continually referenced with the body during the build to ensure the polygons in the neck can be attached easily to those of the torso.

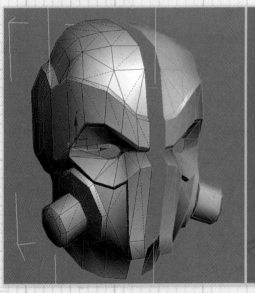

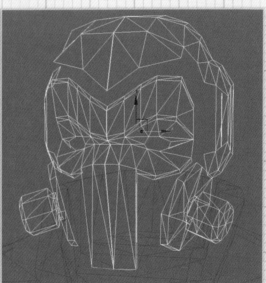

◀ STEP 7: Mirroring

As with the body, the head is constructed as one half, copied, and mirrored to make it complete. Careful inspection of the quality of the model mesh is required to make sure it is well ordered.

◀ STEP 8: Polycount

The head has a higher density mesh than the body; the form of the character's face is very important.

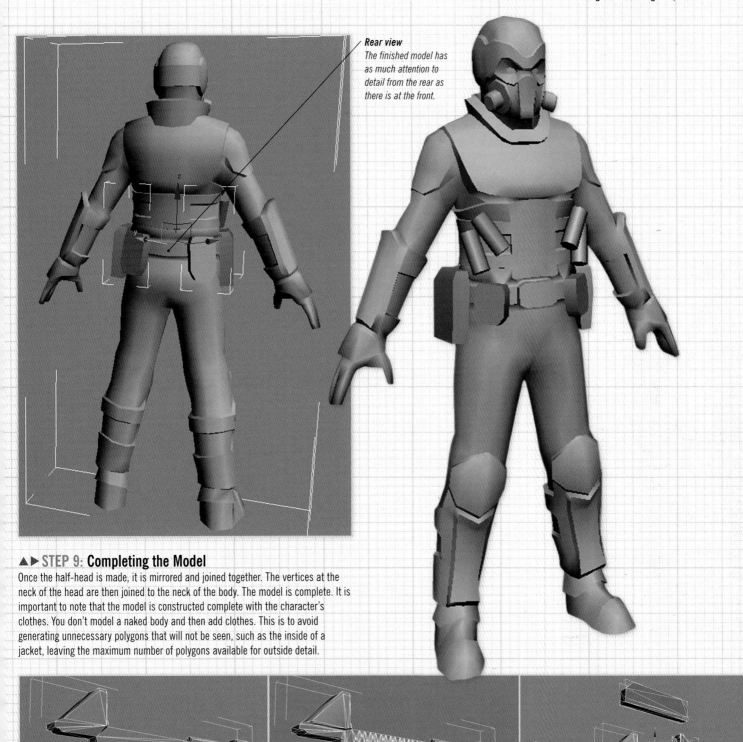

Rear view
The finished model has as much attention to detail from the rear as there is at the front.

▲► STEP 9: Completing the Model

Once the half-head is made, it is mirrored and joined together. The vertices at the neck of the head are then joined to the neck of the body. The model is complete. It is important to note that the model is constructed complete with the character's clothes. You don't model a naked body and then add clothes. This is to avoid generating unnecessary polygons that will not be seen, such as the inside of a jacket, leaving the maximum number of polygons available for outside detail.

▲ STEP 10: Props

This character has a prop – his gun – and this too requires modelling, with the same attention to detail, poly count and reference to the artist's designs. Modelling clothes and making extra adornments that are not part of the character is only done for high-end animation purposes where effects such as the folds of cloth or hair are required. In some instances, in-game clothes may be modelled separately, for example, to allow a cape to move naturally. Other items that move independently of the character may be modelled as well, but this is usually reserved only for the main character.

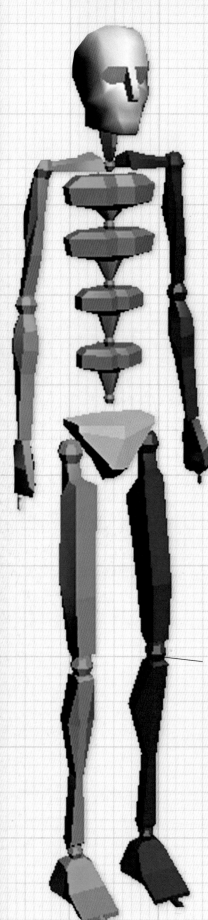

RIGGING YOUR CHARACTER

The finished character model is simply a solid block like a statue; it cannot move or be moved as required for the game. In order for it to become animated, it requires a skeleton to be placed inside it, which can be moved in a similar way to a human skeleton. This process is often referred to as 'rigging'. A humanoid skeleton, or rig, is usually included in a modelling package, and this can be adjusted to suit the tastes of the modeller. It is also possible to adapt and create your own skeletons and rigs within modelling packages.

Movement

Visualize your arm – your wrist (joint), your forearm (bone), your elbow (joint), your upper arm (bone) and your shoulder (joint). There are two bones and three joints. Your arm joints can only move in certain ways – they cannot twist in every direction, and there are limits to your movement. If you want to put your hand above your head, all the other bones and joints have to move as well. This is a demonstration of how inverse kinematics works. A rig is made from bones and joints (to use the skeleton analogy). Each bone will be connected by a joint and there will be a hierarchy of movement dependency established. Additional control handles are often created to make it easier for the animator to select and move parts of the body. You might think of it as a virtual puppet.

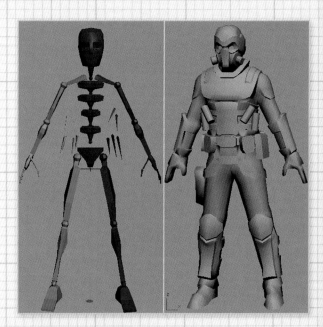

▲ STEP 11: **Attaching a rig**

To rig a model, you first need to insert the rig, either supplied by the modelling program or custom-built. This sits inside the model and is only visible in the modelling program. The next stage is to relate parts of the model mesh to the rig – this tells the program that when a certain bone or joint moves, the model should move in the same manner. So, if you take the hand bone of your character model and move it above its head, the rest of the arm should move with it, as a human arm would. The rig (left) must be placed within the finished character model (right) before the character can be animated.

▶ STEP 12: Building realistic joints

If you look at your arm again, you will notice that when you bend it at the elbow your skin on the outside and inside of your arm flexes to accommodate the movement. When building an in-game character, special care is taken over the places in the model where joints will be, and they are modelled and weighted across the joints in a manner that will make them appear natural when they bend. Again, there are no hard and fast directions here, and knowing how to effectively build realistic joints comes with practice and experience.

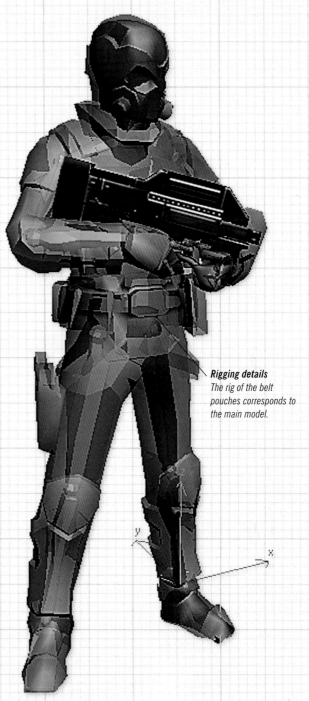

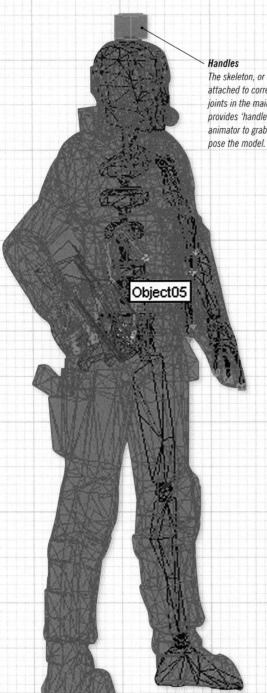

Handles
The skeleton, or rig, is attached to corresponding joints in the main model. This provides 'handles' for the animator to grab in order to pose the model.

Object05

Rigging details
The rig of the belt pouches corresponds to the main model.

◀ ▲ STEP 13: Rigs for objects

Rigs in models need to not only be applied to the figure, but to anything that might move with the character. You may note in the initial trooper rig illustration that there are several pieces of skeleton around the waist area. These are applied to the pouches and equipment linked to the trooper's vest to give them the ability to animate as the trooper moves, and make them bounce realistically as the character moves.

3D surface textures

Textures are placed onto the faces of a wireframe polygon, to give a model its finished appearance. Models are rendered to screen in real time, so during a game they are kept as simple as possible to enable the game to run as quickly and smoothly as it can.

The 'trick' that makes models look realistic lies in the application of texture. It is more efficient in processing terms to have richer textures and simpler model geometry. Our eyes can be tricked into thinking there is more depth and surface detail in a model than there actually is. Skilful texturing is the key to creating realism in game models.

WHAT IS A TEXTURE?
A texture, in game terms, is a small two-dimensional digital image which represents a surface. The view of the texture image is perpendicular to the texture; when it is used, it will be wrapped around the model so that the model appears to be made out of the material the texture represents.

WHAT FORMAT ARE TEXTURES?
Typically, a texture will be prepared in an imaging program such as Adobe Photoshop. While being worked on, the texture will usually contain lots of information and layers, and will subsequently be saved as a Photoshop file (.psd). When work on the texture is finished, it is flattened into one layer and saved as a jpeg (.jpg) or a bitmap (.bmp). Quite often textures are saved as targa files (.tga) or tiff files (.tif). This is because these file formats can also include an alpha channel, which can be used for other texture effects.

▶ **Gathering textures**
Surface textures are all around you. Keep a sketchbook with photos and sketches of interesting or unusual textures. They might be just what you're looking for to give authenticity to your fantasy environments.

RENDERING TEXTURES

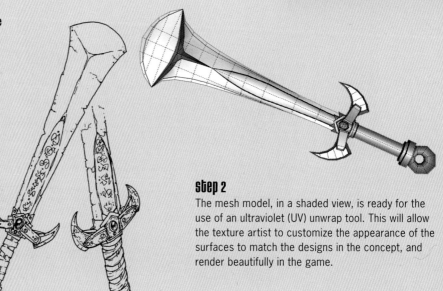

Textures are applied to objects in a game during the rendering process. The object is either rendered on-the-fly, in a real-time game engine, or prerendered, for cinematic sequences. The following sequence shows the stages in a weapon's development, from concept sketch to its final rendered appearance.

step 1
A good concept sketch provides the 3D model builder with a blueprint to build the mesh version of the weapon. The sketch also gives a sense of the weapon's dimensions, and offers the texture artist some visual details for the texture maps.

step 2
The mesh model, in a shaded view, is ready for the use of an ultraviolet (UV) unwrap tool. This will allow the texture artist to customize the appearance of the surfaces to match the designs in the concept, and render beautifully in the game.

WHERE DO THEY COME FROM?

Textures may be either manually painted in a digital imaging program or sourced from photographs of actual textures. The important aspect is that the texture either tessellates with itself or another texture it will be placed against. The idea is that you should not be able to see the join between two textures. This can be very difficult with natural textures gained from photography. Often photographic textures need extensive work in an image-editing program (such as Photoshop) to make them tile seamlessly.

MANUALLY GENERATED TEXTURES

Textures can be created in most image-making programs. Once a texture size is set, an artist can digitally paint a texture using a variety of paint tools. The difficulty with this approach is the need for a high level of skill on the artist's part, to create a texture that is as realistic as possible (assuming a realistic look is required). Painting textures in this way is generally used for inanimate objects, or fantastical creatures that are either easy to represent or have no basis in reality.

PHOTOGRAPHIC TEXTURES

It is simple to record textures from real life with a digital camera. This is particularly useful for representing realistic buildings and people. When getting a photograph for a texture, it is very important that the image is taken at a perpendicular angle and that there is no distortion from the lens. Otherwise, when the image is being edited, it will look as if it is skewed or bulging. Once a suitable image has been sourced, making it tessellate is the next task.

PROCEDURAL TEXTURES

Procedural textures are those that are generated by a programming algorithm. These textures appear natural but are completely computer generated by the use of fractal calculations to give the appearance of richly detailed, repetitive materials such as wood, metal, fur and so on. The reality of the appearance of these textures is a matter of some debate; often, though they seem real, our mind can tell us something is not quite right. No doubt as technology improves so will the realistic appearance of procedural textures.

TEXTURE SIZES

The image size of a texture can vary depending on the machine it is working on. Generally, textures are made up of square or regular shapes to make the tiling process easier. Sizes of texture images are usually square, and must be powers of 2, for example 32, 64, 128, 256 or 512 pixels square. Like polygon counts in a three-dimensional model, the size of a texture also demands processing time. The larger the texture, the more processing required. If you consider that in a typical game there may be several characters, buildings and items in the scene, you can appreciate that this information increases the demand for processing. Texture sizes vary depending upon the machine – typically a major character may have a 512 x 512 texture assigned to it with the possible addition of a 256 texture for the head or an outstanding feature. Artists often allocate additional texture resolution to areas of focus like a character's face. The 'next generation' consoles and PCs support higher graphics processing and are able to present High Definition television images. This means that not only a greater number of textures but also larger textures are possible and are used in the games on these consoles.

MAPPING

Once the texture has been prepared, it is then ready to be placed onto the mesh of the model – this is called 'mapping'. Placing the texture onto the surface of the model will give

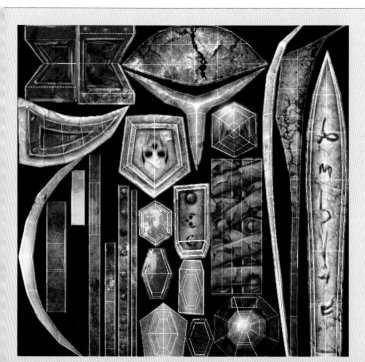

Step 3
The painted image shows the UV layout defining the various details in each distinct segment of the weapon's textures. For example, the dark pointed ridge of the weapon's tip, depicted in Step 2, is its own edge detail texture on the map.

Step 4
The finished rendered weapon shows the beautifully seamless effect of the texture-mapping process, and how the weapon will appear in a game environment.

it the appearance of greater detail without increasing the complexity of the underlying mesh. If the object was simple in nature and only made out of one item, then the task of texturing would be very simple. However, in reality, designers are usually dealing with extremely complex shapes and might need a number of textures to be placed on the surface of the model in order to achieve the desired result. In order to do this they undertake a process called 'UV mapping'. The full term is 'UVW mapping' (usually shortened to 'UV map') where the letters UVW are the coordinates for the texture, just like XYZ (but these are already being used as a reference in the model space). A UVW map is a flat image, the points on which are related to points on the surface of the model. Once this image is created, the UV map can be applied to the model in order to give it its textured appearance.

ALPHA CHANNELS

Textures can add other visual effects to a model beyond simple surface effects. The use of a fourth channel, other than red, blue and green – known as an alpha channel – can make certain parts of the model transparent to give the effect of a window or translucent material. Alpha channels can also add specular information – this indicates whether the item is shiny or not.

BUMP MAPPING

Bump mapping refers to a greyscale texture image. When the image is rendered, the data is used so that a lighter area is 'higher' and a darker area is 'lower'. This enhances the three-dimensional appearance of the object without building in more geometry.

NORMAL MAPPING

Normal mapping works in a similar way to bump mapping, but it uses colour (red, green and blue, as used in monitors) to produce a textured effect. Normal mapping can be particularly effective because a normal map from a high-resolution (high poly count) model can be used on a low-resolution (low poly count) model. The effect is to give the appearance of a high-resolution model from a more efficient low-resolution model. Normal mapping is used extensively in current games, as it gives excellent graphic quality with reduced processing demands.

DISPLACEMENT MAPPING

Displacement mapping uses a greyscale image as an information channel, but this time the data from the tones in the image are used to actually move the model vertices in order to create a textured effect.

VERTEX AND PIXEL SHADERS

These aspects of texturing and modelling are key to visuals in games. Shaders can affect the final appearance of a model's surface, such as the amount of light reflection, how the light is diffused, and further effects on texture, refraction, shadows and other aspects. Vertex shaders work on the vertex level of the

TILING A SURFACE TEXTURE

In this exercise, you will make a simple wall texture that will seamlessly tile when placed in an environment. First get an image of a standard stone wall (such as your own garden wall). Note that the image used must have been taken perpendicular to the wall.

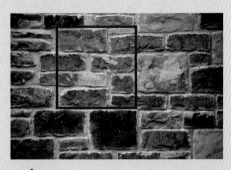

▲ **step 1**
Open the image up in your image-manipulation program (Adobe Photoshop, in this example). Then choose an area roughly 512 pixels square. Be careful to pick a section that has no strong features in it. Check where your edges are, and try to guess ahead by selecting along mortar lines. Select from the middle of the image, as at the edges of a photograph there may be some 'bulging' effect due to the nature of the camera lens.

▲ **step 2**
Size the image to exactly 512 pixels square, trimming and making sure that mortar lines are horizontal.

▲ **step 3**
Now comes the clever bit. In Photoshop, there is a filter called 'offset'. This filter cuts the image into quarters and swaps them around as in the diagram. Set the filter to wrap around and the offset to half of the image size – 256 pixels. The edges of the image will now match up to the corresponding edges of the adjacent images when tiled.

The joints in the texture can be seen. They need careful digital painting to remove them.

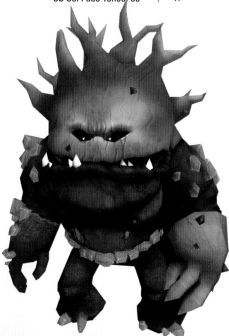

model mesh while pixel shaders work on the colour of individual pixels in the image.

FUTURE DEVELOPMENTS

With the increase in speed and processing power of PCs and consoles, there are sure to be many new developments in modelling and texturing. Vertex and pixel shading are features of many game engines and many special visual effects are delivered via texturing techniques. One such development is the mega texture. Developed by id Software, mega textures have been developed to represent large-scale environments (such as outdoors) without the drawbacks of repeating textures forming visible patterns in the landscape. A mega texture can be 32,000 x 32,000 pixels square (1 giga pixel), which can cover the polygonal mesh of a landscape with a single texture. This gives a unique and highly detailed non-repeating terrain over a large play area. The code behind the mega texture can also hold information about the terrain, such as ambient sound and physical properties, in an efficient manner. It is thought that this approach will give better, more detailed scenes as opposed to current technologies using tiled textures.

The raw power in the newest machines means that they can utilize larger tiling textures and output them at HDTV resolutions. The increase in power can also support higher polygon models and present more surface detail and texture, giving a richer, finer image. The job of the texture artist will be to continually develop techniques to deliver ever more visually believable worlds.

THINK IN BOTH DIMENSIONS
The texture artists work up their texture art in a 2D UV layout, but they must first understand the complex protuberances and cavities that make up the rigged model, which exists in three dimensions. Being able to think of the 3D potential of a 2D unwrap and vice versa is an invaluable skill.

Blur Tool — R
Sharpen Tool — R
Smudge Tool — R
Clone Stamp Tool — S
Pattern Stamp Tool — S

▶ **step 5**
Now you should have a brick wall with a seamless texture, 512 pixels square. If you create a larger canvas and match up four examples of your texture side by side, they should tessellate seamlessly.

▲ **step 4**
There are now visible seams in the middle of the image that must be removed. This is done manually by working along the seam and painting over it with a selection from elsewhere in the image. In Photoshop, the Clone tool allows you to select a piece of the image from another area and paint it in. This has the effect of hiding the seam. Other useful tools for hiding edges are the Blur and Smudge tools.

ILLUSION OF COMPLEHITY

The images on the opposite page show a gritty, complex warehouse interior, with striking light effects. This is a perfect scene for game action to take place, with a wealth of detail and atmosphere – each surface bears the marks of industrial use.

Compare this with the flat colour version of the same interior below. This interior has lighting, but the walls and containers are simple, smooth polygons. The polygons are coloured with a default grey tone and have no associated textures. If you look at the square textures on this page you should begin to spot these individual images in the scene on the opposite page. The texture detail has given the impression of more complex surfaces. By putting detail in the colour textures we are able to reduce the complexity of the polygons needed to create the scene. Some of the textures are also tiled, or repeated on surfaces to save even more memory.

▼ Lo-res Textures

Onscreen textures are lo-res – 72 DPI, the same as a monitor or TV screen. They can look extremely simple when reproduced in print. But when they are used together in a game, they can create a very convincing effect.

Girders and Roof

Walls

Floor

Details

Cargo

▲ Textured Mesh

Cargo textures have been used to make simple meshes appear as cargo-type objects in the scene.

▼ Ready for Texturing

An untextured interior ready to be 'surfaced' with some of the swatches at right.

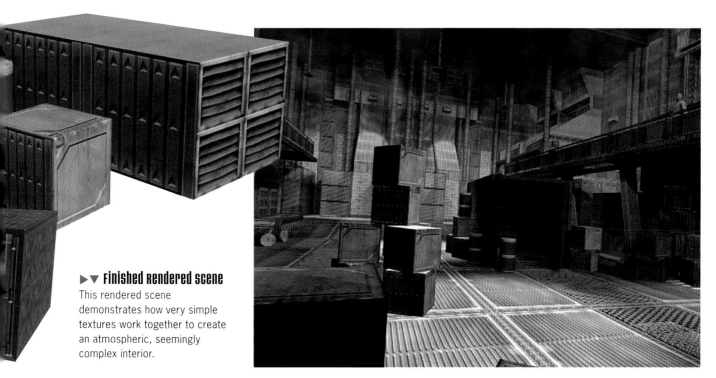

▶▼ **finished rendered scene**
This rendered scene demonstrates how very simple textures work together to create an atmospheric, seemingly complex interior.

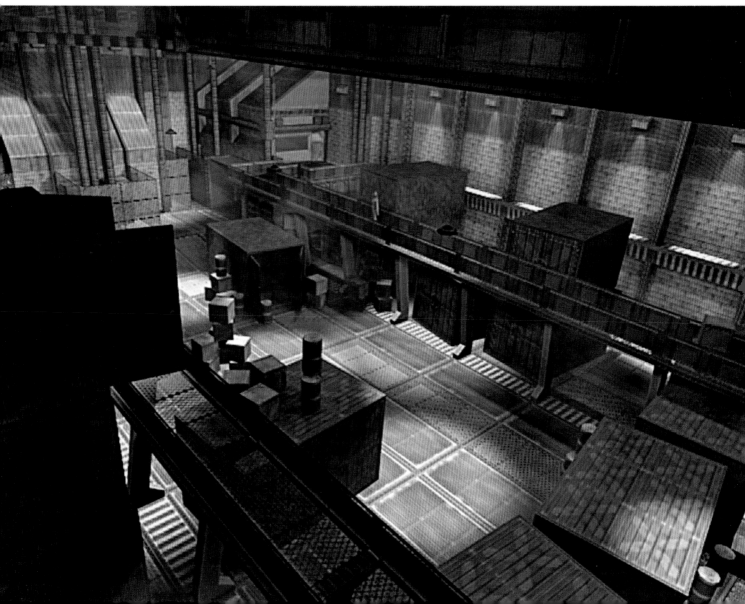

03 BRINGING IT ALL TOGETHER

Now put all the skills you've learned together. This unique 'behind-the-scenes' analysis, presented by industry expert Joe Shoopack from Sony Online Entertainment, takes a well-known and well-loved fantasy character from initial rough through to its final stages.

From Concept to Digital Model

The fantasy-based game EverQuest II contains some incredible creatures for players to fight. Multiple artists are involved in the creation of each character. From concept to final in-game model: Traditional art skills, 3D modelling, texture mapping, rigging, and animation are some of the key skills involved in bringing these creatures to life.

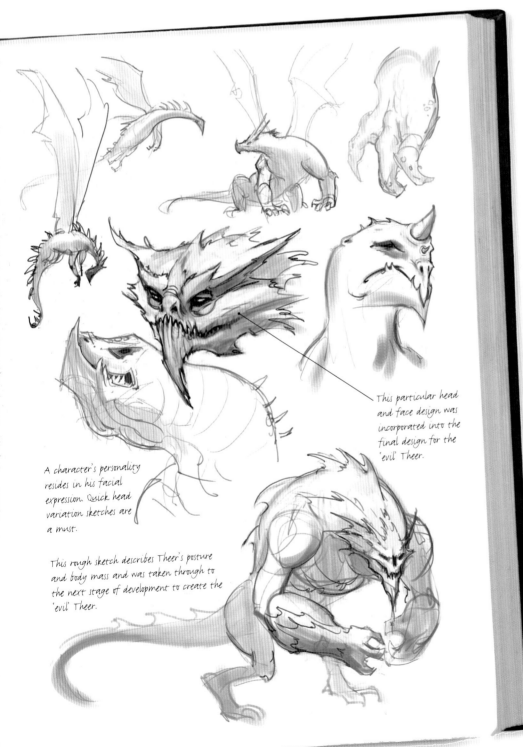

This particular head and face design was incorporated into the final design for the 'evil' Theer.

A character's personality resides in his facial expression. Quick head variation sketches are a must.

This rough sketch describes Theer's posture and body mass and was taken through to the next stage of development to create the 'evil' Theer.

STAGE 1: CONCEPTUALIZING YOUR CHARACTER

It all starts with a description put together by one of the game designers. This designer description gives some basics about the character, but also leaves the artist room to be creative and inventive. The concept artist and game designer work on designs together until a satisfying concept is reached that meets both the designer's intended function for the creature and the artist's vision. Here is the design description the artist worked from to create the character of Roehn Theer:

'The God and sentinel, Roehn Theer, was appointed to keep the balance between good and evil within the EverQuest universe. He should be a very large fearsome winged creature able to function on the ground, in the air or the void. He wields two majestic swords and can appear in an "evil" or "good" form.'

◀ Keeping a sketchbook

The concept artist will spend time quickly exploring possible looks to discuss with the designer and art director. In the initial discussions, we decided Theer would be lizardlike, so the concept artist tried several approaches in that direction. The Texas horned lizard was the inspiration for some of the facial details and we felt the two-legged stance suggested intelligence.

STAGE 2: FINALIZING THE CONCEPT

After the initial concept phase is over and the artist has explored variations in figure composition, facial expression and many of the other aspects of conceptualization covered in this book, the concept artist moves onto developing a more finalized version of the creature that a modeller and texture artist can use as a guideline for building the in-game version.

CONCEPT ONE: EVIL THEER

Once all the sketchbook ideas have been discussed by the artist, art director, and lead designer, it's time for the artist to start creating Theer. The artist preferred to start with the evil version. Later, he will modify some details to create the good version.

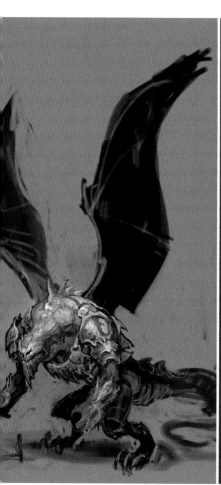
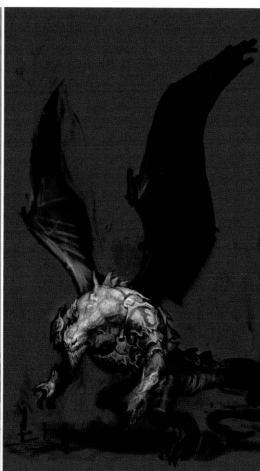
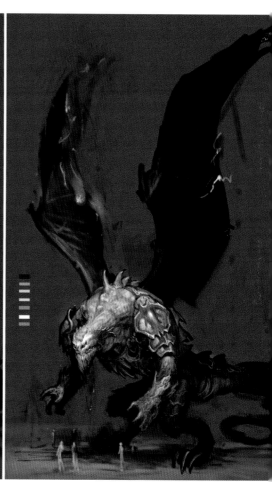

Step 1

Working in Photoshop using a Wacom Cintiq (drawing directly on the screen with a stylus), the artist defines a final look for the evil version of Theer. The artist starts with a greyscale value study; introducing colour too early would make the distribution of light and dark values difficult to evaluate.

Step 2

Now he creates a more finished piece that introduces light sources to help convey a mood. In this case, the artist is showing the creature coming out of darkness into light, as well as giving a feeling of 'heaviness' and bulk to the upper torso that makes the viewer feel this is a fearsome creature.

Step 3

The final colour version is now created. Referring to the palette swatches on the left helps the artist keep the colours to the range he desires. Additional fine details and highlights are added. Some figures are added in the foreground to give the 3D modeller a sense of scale.

CONCEPT TWO: GOOD THEER

With the first finished concept completed the artist now turns to creating the good version of the character.

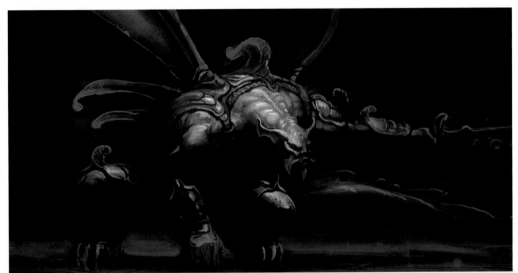

step 1

The artist decided to put some additional focus on the head details in the 'good' version of Theer. This detailed work is rendered in Photoshop in a greyscale digital painting. When these concept illustrations go to the character modeller, the modeller will have a chance to refine some of the details on his own, but will continue to refer back to the greyscale and colour concept images to make sure he stays true to the overall presentation of the creature.

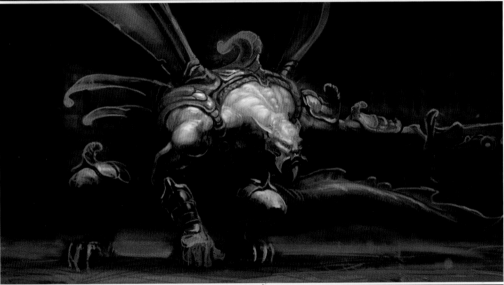

step 2

The artist experiments with colour variations distinct from the evil version of the character. After discussions with the art director, it was decided that evil Theer would be getting some fire and heat effects and, to distinguish good from evil, that the good version should be rendered in a cooler colour like green. In addition, the skin tone would be lighter – a stark contrast to the darker skin tone of the evil version.

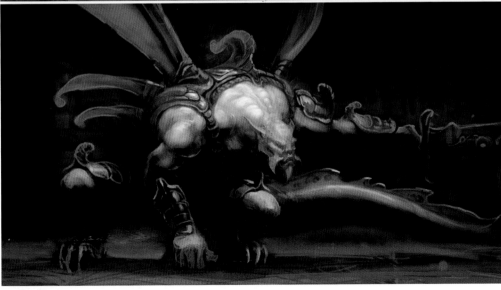

step 3

The concept artist reviewed the progress with the art director and a lighter colour was decided on for the final concept. To accomplish this, the green version shown in Step 2 was used as an underpainting and the skin tone was painted significantly lighter while allowing some of the underpainting to show through.

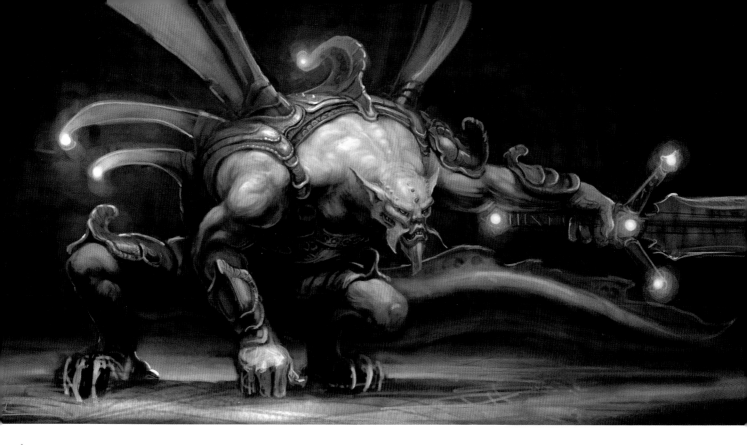

step 4

In the final version, additional fine details were added as well as some desired glow effects. The art director and lead designer felt that the glow effects should be added to 'dress up' the creature and to add extra visual interest. This piece is ready to pass to the modelling and texturing artists.

STAGE 3: DIGITAL MODELLING

There are several 3D modelling packages to choose from. *EverQuest II* uses Autodesk Maya. The concept art is used as a guideline and a three-dimensional version of the creature is created. At this stage, it is just a grey-toned model. The model or '3D mesh' is created with enough polygon edges to enable the model to bend during animation and maintain the integrity of its shape. Just enough polygons are used to maintain the shape and silhouette. It takes system processing power to display and animate the model, so polygon use needs to be efficient and cost-effective. See pages 62–67 for more information on digital modelling.

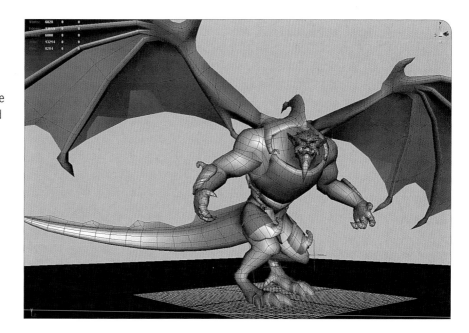

3D mesh

The modeller used Maya as the 3D art program here. Referring frequently to the concept art of the concept artist, the modeller has the opportunity to add a few of his own nuances that look good from all angles – as long as he stays true to the key qualities of the concept piece. Theer now exists in three-dimensions.

STAGE 4:
ADDING TEXTURES

At all major stages of construction, the work is reviewed by the team's art director to ensure it is meeting quality and technical standards and staying true to the concept work. Shaders are created for the model to display qualities such as: colour texture, specular quality and the illusion of depth in details. Shaders can have multiple texture components. The one used for Theer has three: the colour map, the specular map and the normal map. Turn to page 68 to learn more about 3D surface textures.

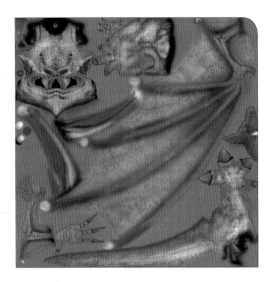

colour map
Pixels on the textures must be placed onto the mesh. The mesh gets programmatically flattened into a 2D space. The triangles on the flattened-out image can be painted over and the image will be mapped back onto the mesh. The colour texture map shown above is painted in Photoshop and provides the base look of the creature.

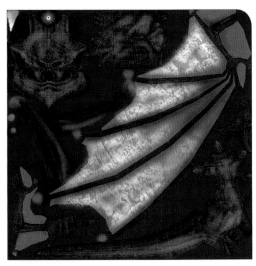

specular map
A specular map is also created. This map defines the level of 'shininess' the surface has. The black areas on the map will appear dull; the light areas of the map will appear shiny. In this case, the interior flap portions of the wings will appear more shiny than the body.

normal map
The third component used is called a normal map. Every pixel on the model will receive light. This map defines how much light individual pixels will receive relative to the light source in the game. It creates the illusion of depth and additional geometry details.

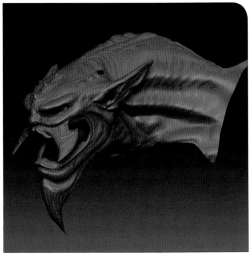

High-Detail Mesh
Normal maps can be created with the high-detail modelling tool called ZBrush. This program allows users to sculpt incredible detail, too much detail to render as actual 3D geometry in the game. However, ZBrush has a function that can generate a normal map from the high-detail sculpt.

textured characters

Textured versions of good and evil Theer are shown here in side view. The characters look quite different and yet they can be easily understood by the player to be two aspects of the same creature. The elements of colour (that were evident in the conceptualizing stage) and the alterations in modelling detail, have yielded two distinct looks that use a single 'skeleton' and an identical set of animations.

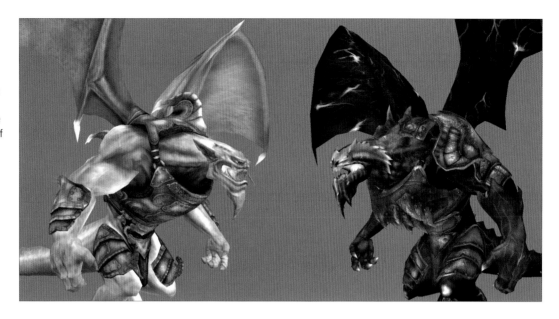

STAGE 5: RIGGING AND BINDING

Now that the model is built and textured, a skeleton and movement controls are created, and the textured model is attached to the underlying skeleton. Creating this control structure is called 'rigging'. The end result will be a model that can be manipulated by the animator to create all the creature's actions.

▶ step 1

A skeleton is created for the finished model. Each of the small circles are the rotation points of the joints. The model will only bend at these points, and definitions can be set for degrees of rotation allowed. Like polygons and textures, the more joints you have, the more processing power it will take to animate.

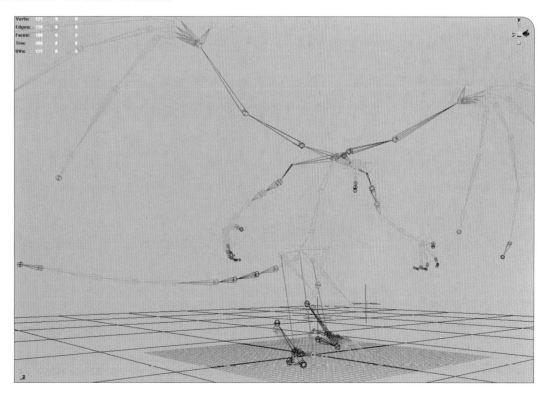

▼ step 2

The skeleton, now properly placed and sized to fit inside the model, is attached to the mesh. This process is called 'binding' or 'weighting'. Creating skeletons and rigs for games is a delicate process: you need to use just enough bones to animate the creature convincingly.

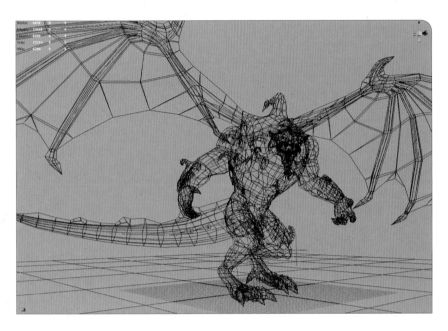

▶ finished model

Once all these steps are completed, the model is exported from the development software into the game environment. Combined with a spectacular environment, in-game lighting, music, sound and visual effects, it becomes a fearsome opponent for players. The good and evil versions of Theer are featured on the box cover of the latest *EverQuest II* release, 'Sentinel's Fate'. Go to www.everquest2.station.sony. com for more details. When playing the game, notice the variety of player races and creatures that are needed to make a convincing MMO fantasy title. Pay attention to how variations of creatures are used to populate different areas of the game. See if you can identify which creatures may use the same animators under very different-looking exteriors. Constantly creating new creatures and new variations on existing creatures keep games like this fresh and fun to play.

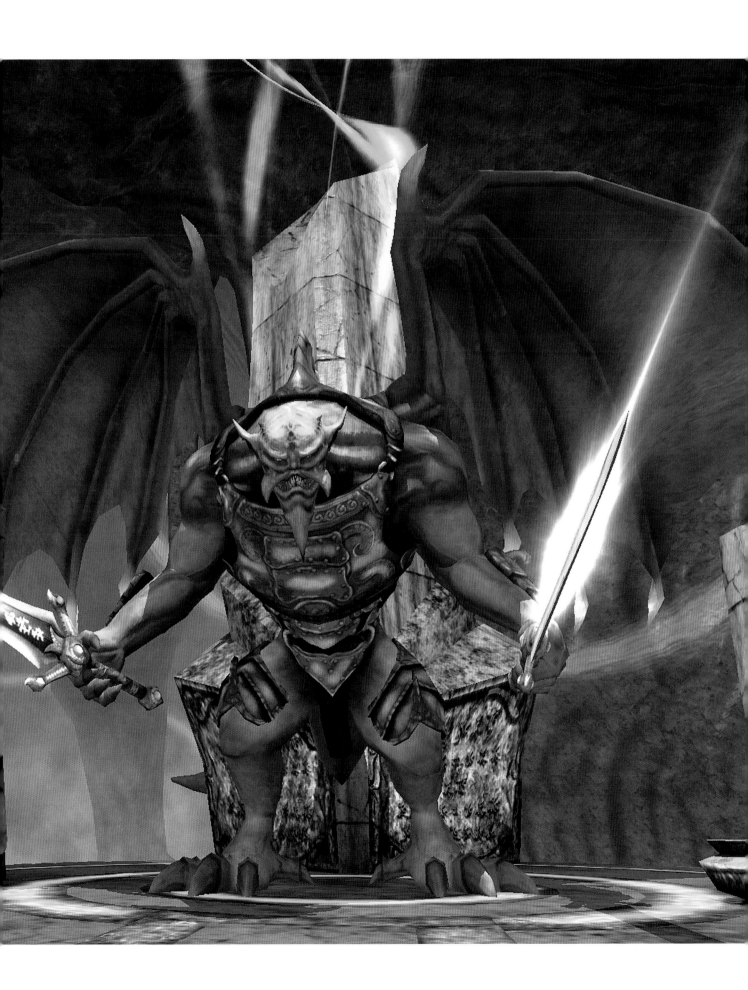

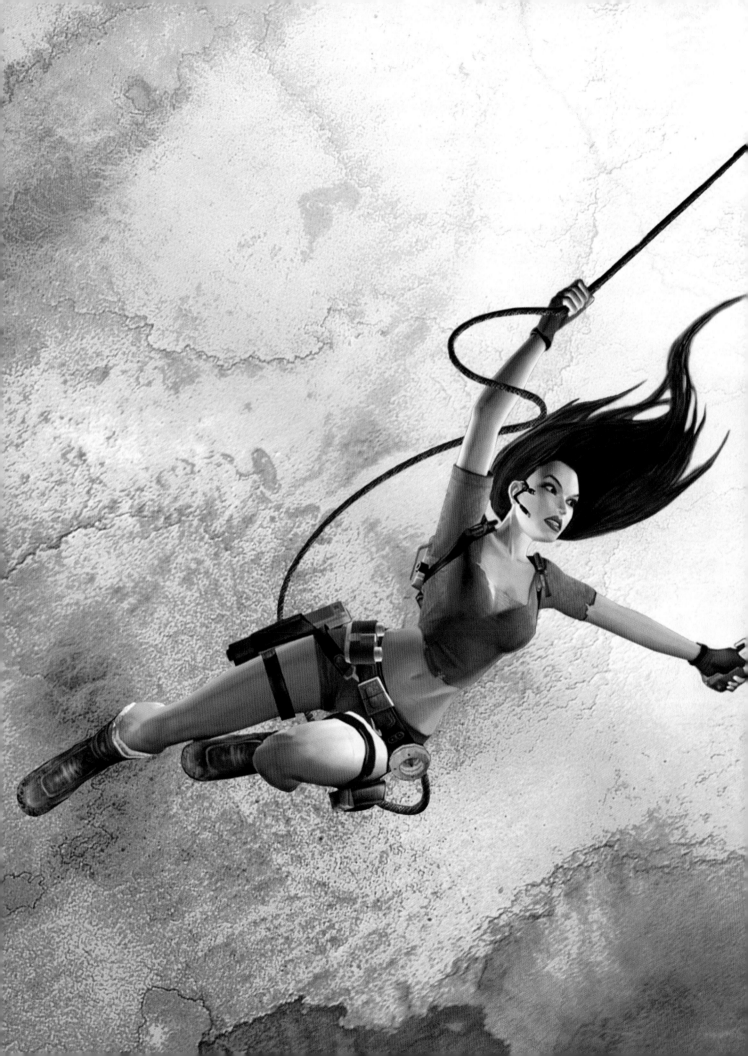

04 THE GALLERY

A visit to a gallery or an art
museum is always a source of
inspiration. The following pages
are devoted to some of the
most talented artists in the
game industry, and may
provide the stimulus you're
looking for to create
masterpieces of your own.

Warriors and Weaponry

▶ Forbidden Zone by Daryl Mandryk

This mobile, fast-moving character needed a weapon that suited his personality, and twin Uzis, with their high rate of fire, seemed like a good choice. When it comes to character art, drawing and painting from life is the best training. Once you have a handle on the basics of constructing figures, you can let your imagination get to work.

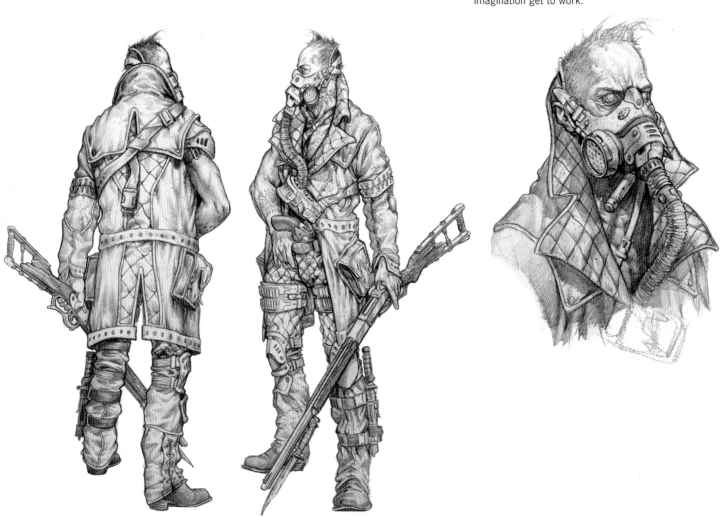

▲ Post-Apocalyptic by Grant Hiller

The head concept was the starting point for this post-apocalyptic character, and the rest of the costume was developed from that initial sketch. The addition of a weapon should serve to suggest something about the character and the world he is from; in this case, a world where resources are limited, so the inhabitants must find uses for junk. This character has an old Winchester-style rifle, because he doesn't like to get too close to his enemies: he'd rather take them out from afar. He's had to repair the stock and has fixed an old knife at the front to function as a spear.

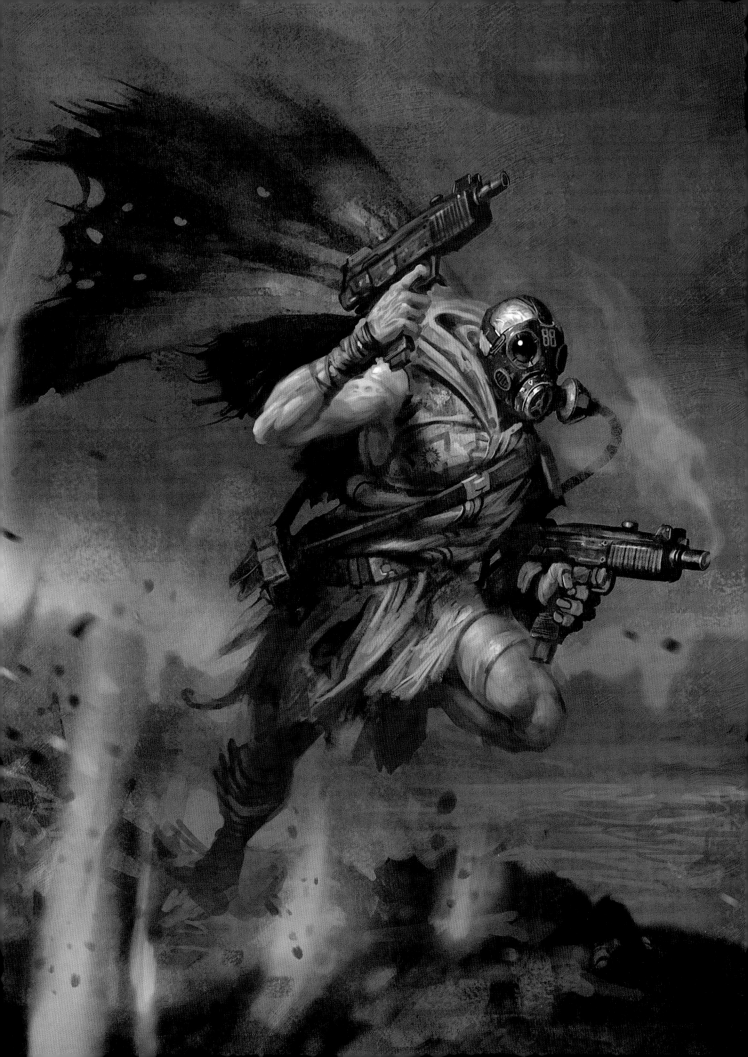

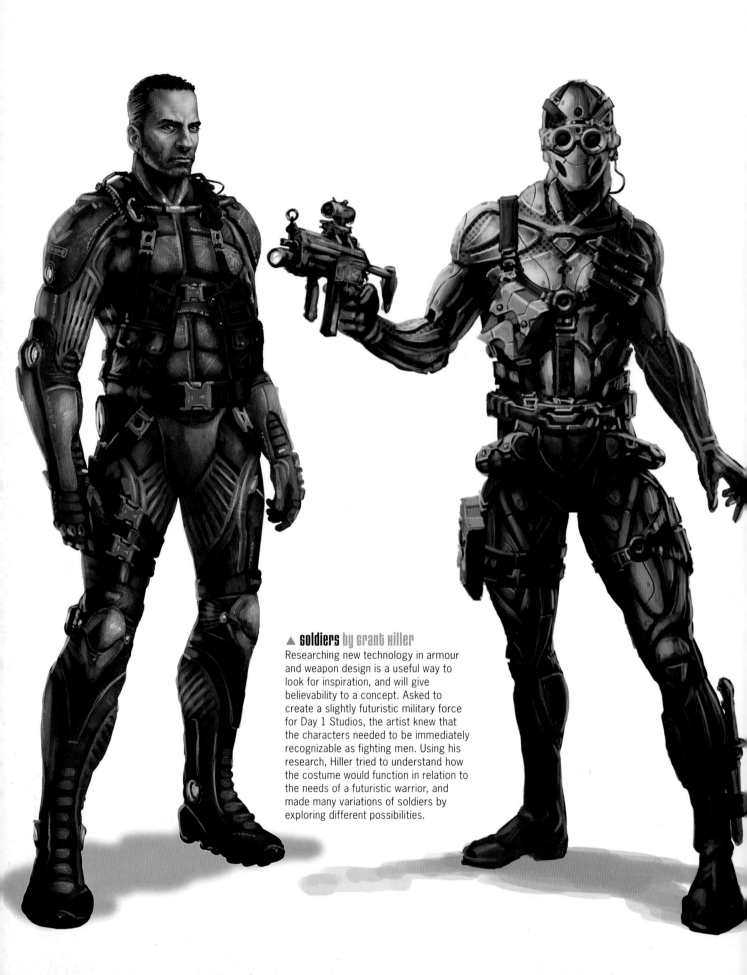

▲ **soldiers** by grant hiller
Researching new technology in armour and weapon design is a useful way to look for inspiration, and will give believability to a concept. Asked to create a slightly futuristic military force for Day 1 Studios, the artist knew that the characters needed to be immediately recognizable as fighting men. Using his research, Hiller tried to understand how the costume would function in relation to the needs of a futuristic warrior, and made many variations of soldiers by exploring different possibilities.

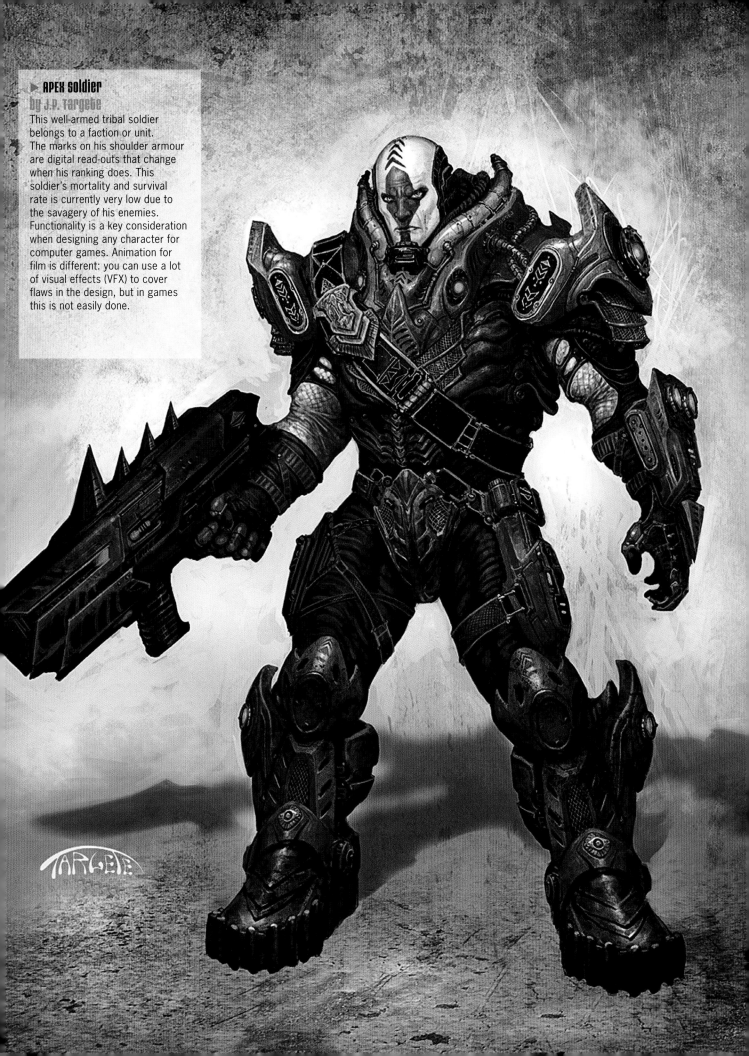

► APEX SOLDIER
by J.P. Targete

This well-armed tribal soldier belongs to a faction or unit. The marks on his shoulder armour are digital read-outs that change when his ranking does. This soldier's mortality and survival rate is currently very low due to the savagery of his enemies. Functionality is a key consideration when designing any character for computer games. Animation for film is different: you can use a lot of visual effects (VFX) to cover flaws in the design, but in games this is not easily done.

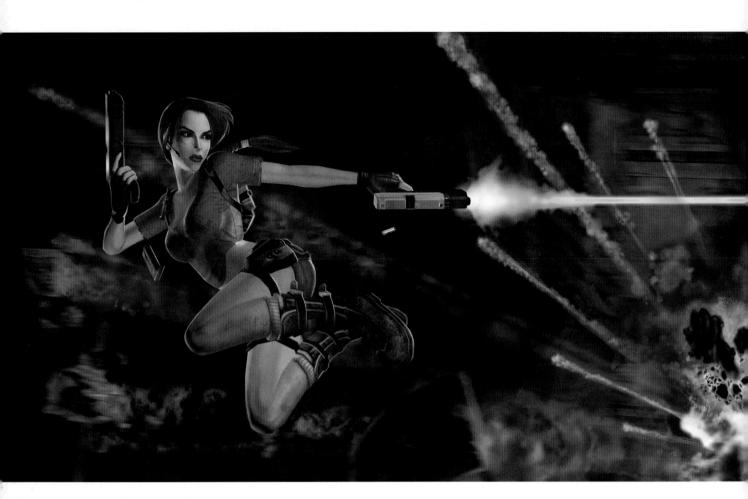

▲ **JUST MISSED HER** by Daniel Cabuco

The brief from Crystal Dynamics for this key art piece aimed at selling *Tomb Raider* was to create a series of images to show off the redesigned Lara Croft and new game. The piece needed to scream action, so the artist brainstormed various ideas and collaborated with the series creator and PS2 art director to come up with a final pose. Lara Croft, intrepid explorer and adventurer, has once again found 'a spot of trouble'. In this case, it results in an exchange of gunfire with some bad guys, who have brought in the big guns, and Lara is forced to jump out of the way of a rocket. Lara was posed in Maya with assets from the game, then painted over in Painter and Photoshop. The piece looks more interesting and less static than a pure 3D render would, and does what it is meant to do: get people excited about the project.

▶ **ONE MUST FALL** by Daryl Mandryk

Painting characters who appear to have the odds stacked against them makes for great drama. The artist started work on this personal piece with very loose, sketched ideas, then developed the image by adding colour and texture, refining or simplifying as necessary. It is important that you consider what is not working, as well as what is, ensuring that you balance all the elements of a painting into a unified, cohesive whole.

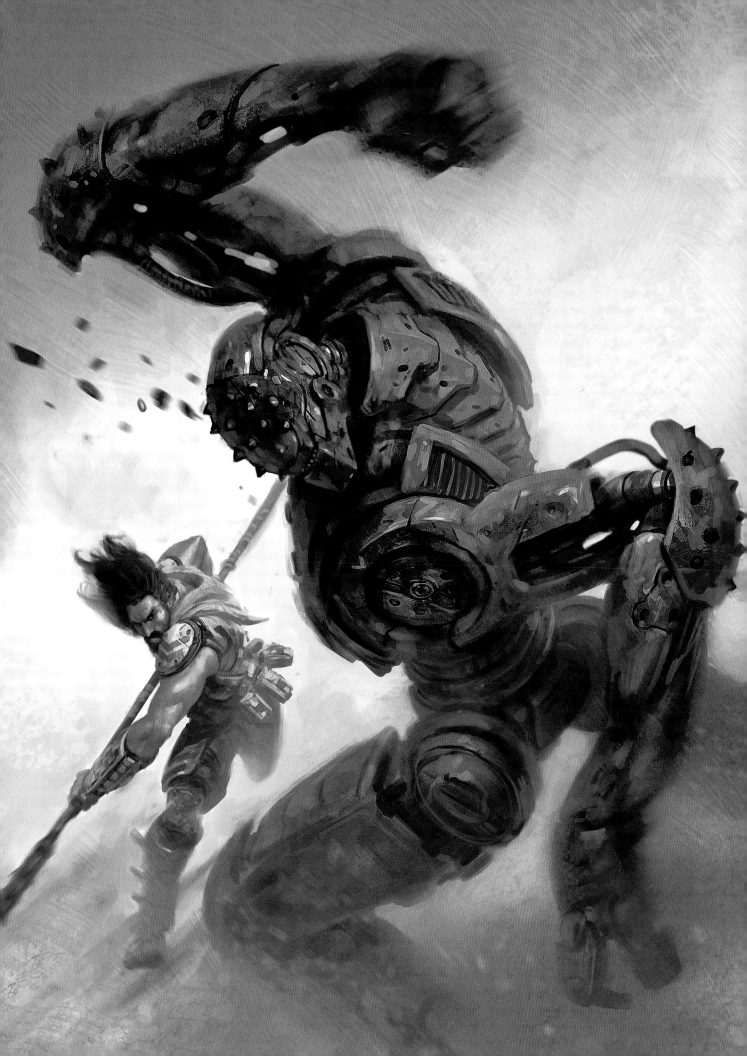

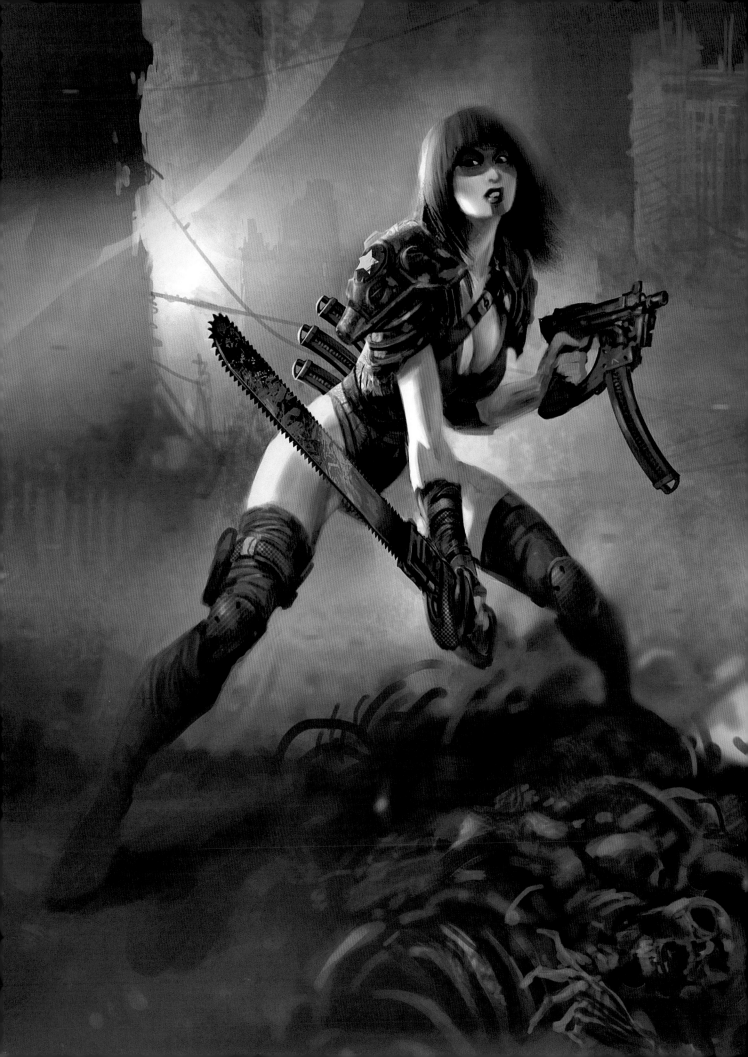

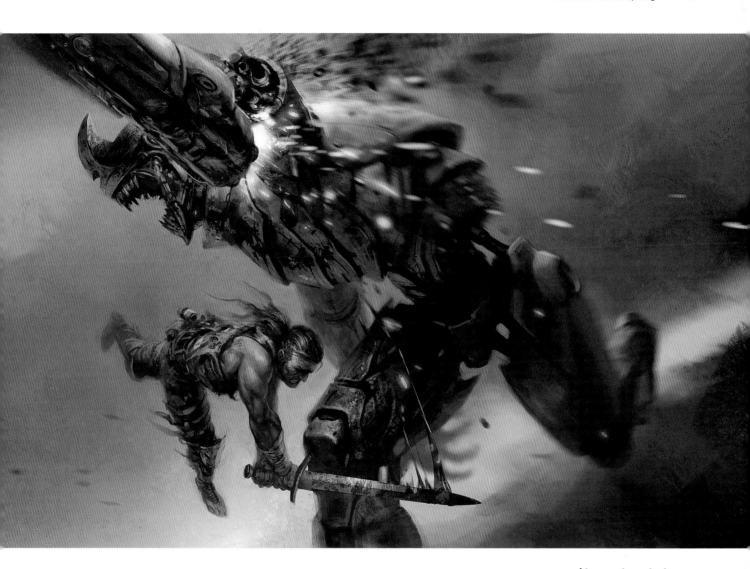

▲ **unarmed** by Daryl Mandryk
Mandryk pulls his characters from a futuristic, post-apocolyptic world that resides in his head. Every now and then, he simply sits down to explore that universe. There are always plenty of revisions in his work, from repainting small details to revising entire character poses.

◄ **Renegade** by Daryl Mandryk
Putting characters in hostile environments can create empathy towards them, and conveying their personalities as tough as nails – people that can handle themselves – makes them the kind of characters a player would want to play in a fantasy video game.

Fantasy Creatures

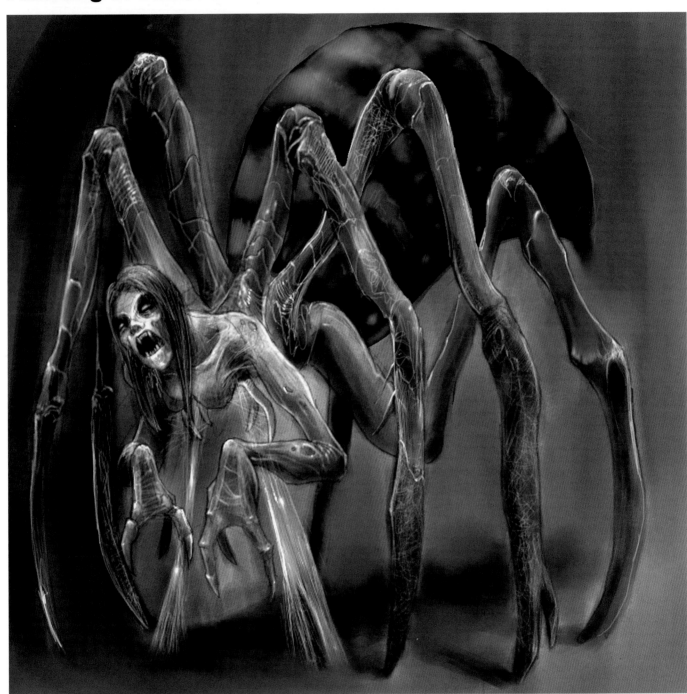

▲ **Arachnid Queen**
by Daniel Cabuco

Developed by The Collective and featured in *Buffy the Vampire Slayer* for XBOX and PC, this piece was generated in response to a brief for a spider woman, who could seduce and kill members of the football team in Sunnyvale. Cabuco began by studying various spiders and watching ghost movies for inspiration. After several drafts, the Lead Designer approved the design. Great concept art like this should ignite the imagination and guide the 3D artist. People should be excited to bring it to life.

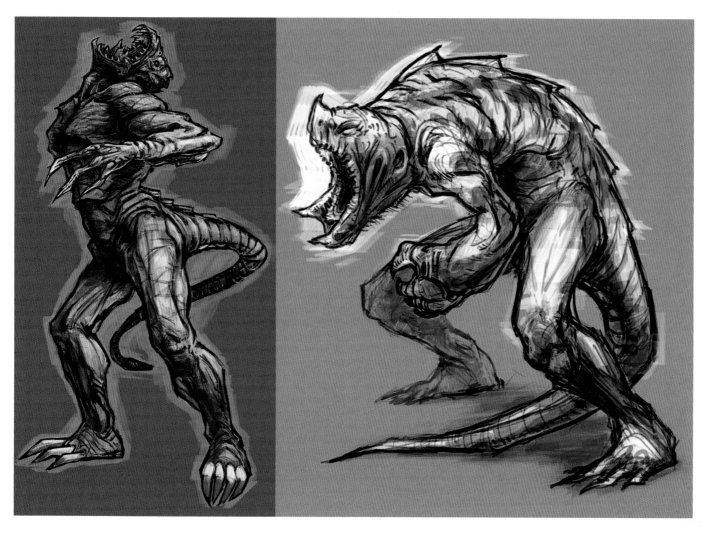

▲ Horror Monster Roughs
by Lee Petty

These two humanoid monster designs were created during a pre production period at Crystal Dynamics, between games. The creatures are from a series of quick sketches done entirely in Photoshop.

▼ Deep Cave Serpent by Daniel Cabuco

This concept was created in response to a brief from Eidos asking for an underwater monster. The artist chose to mix a moray eel with a tiger fish and blind cave fish for the eyes and colouration. He carried out a lot of research, looking at various deep cave animals. Tiger fish flare up when threatened, so the artist used this as a way to tell the player when to dodge or take cover. There was a polygonal limit to the creature, and game play wasn't yet worked out, so Cabuco spent the polygons on the head, making that as interesting as possible; the tail and body served only as decoration.

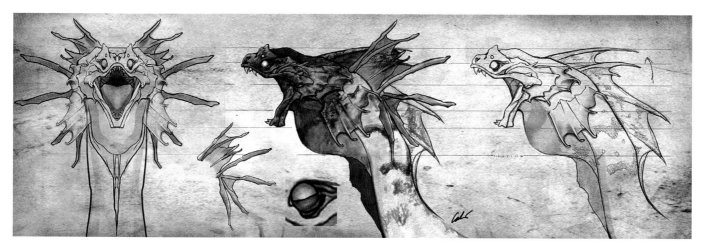

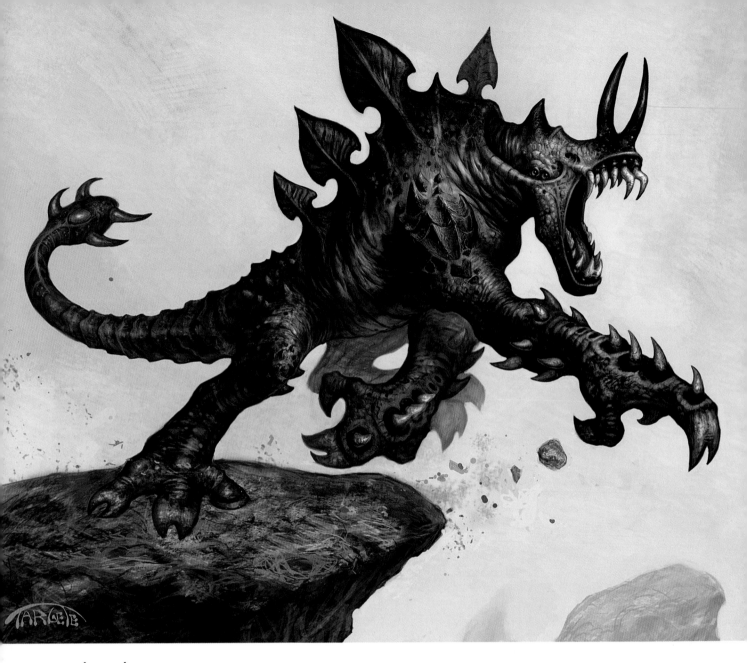

▲▼ flare Gasher
by J.P. Targete

This design was created for a client's massively multiplayer online role-playing game (MMORPG). Indigenous to an alien planet, the Flare Gasher roams the world freely and is highly dangerous. It is equipped with a hydrogen-producing gland. When ignited by a flare sparked by an organ in its throat, it spews out a fiery flame not unlike a dragon. The preliminary thumbnails below show the type of creature the Gasher had to be. Its skin had to be tough and heat-resistant and it had to have finlike bone growth on its body. These attributes were a must for the design, but everything else was up for grabs, so Targete had a reasonable amount of freedom. The client finally went with the fourth design on the far right.

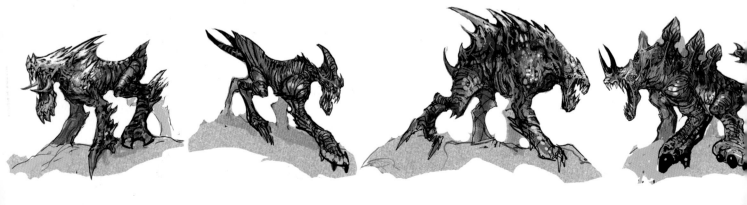

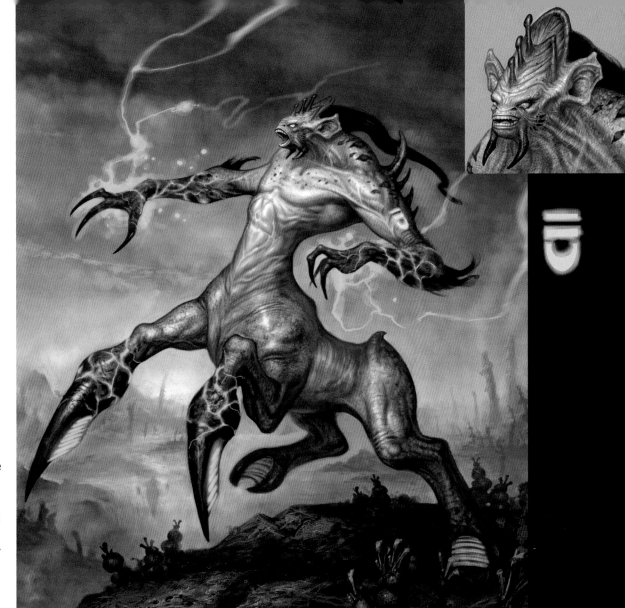

▶▼ Gax Discharger
by J.P. Targete

Though this creature may look centaurlike in appearence, it is actually an alien species. The colour piece was created first and taken to a finished level. Model sheets (or orthographics) like the ones below were then created from this high-detail colour piece. The model sheet is very important for the modellers. In this case, the design was created in the U.S. and sent to China for 3D modelling, which is why it was necessary to create such a detailed set of images in order to get accurate models that were faithful to the original designs.

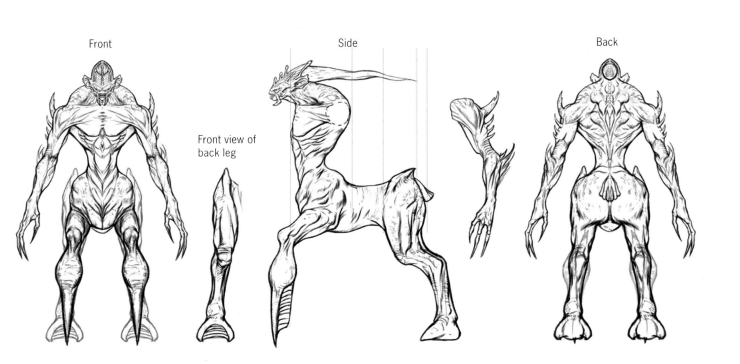

Front

Side

Back

Front view of back leg

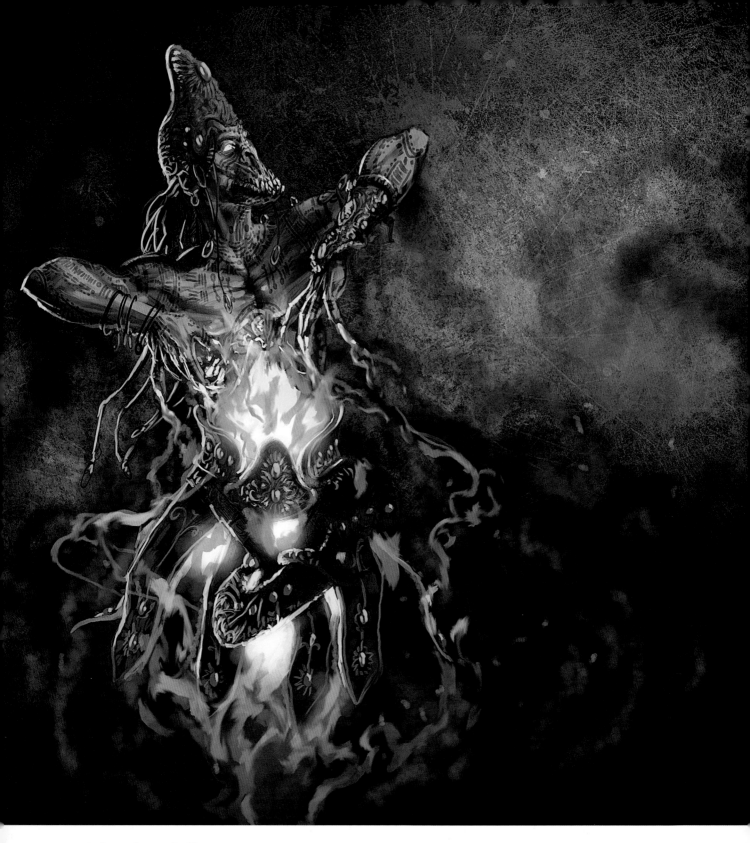

▲ **Dark Shaman** by Grant Hiller

The artist's love of dark fantasy inspired him to
create this piece, depicting a shaman emerging from
the darkness, being made flesh and blood by the
sheer force of his malevolent will. An initial ink sketch
on paper was scanned and overpainted in Photoshop,
realizing the forms and lighting to give the proper
mood of the piece. It was important that the shaman
maintained an ethereal quality, established by him
having emerged from an undefined, nebulous area.

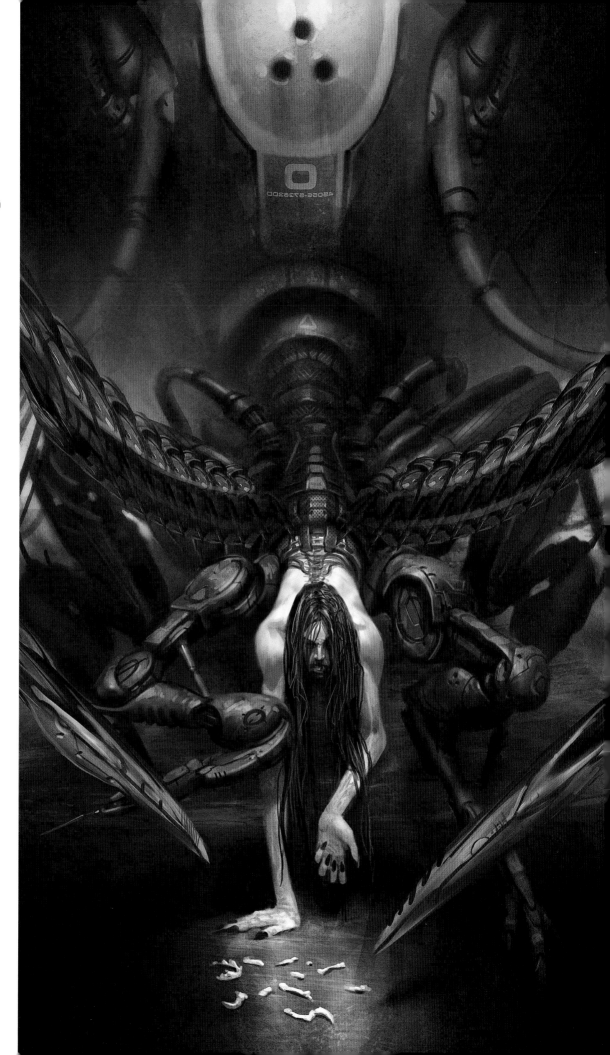

▶ Bone reader
by daryl mandryck
This striking image was painted in Photoshop and depicts an archetypal character that gameplayers might seek out to help them in their quest – someone who provides critical information in return for a price. The limbs appear half-insect, half-machine, which creates an unsettling feeling in the viewer.

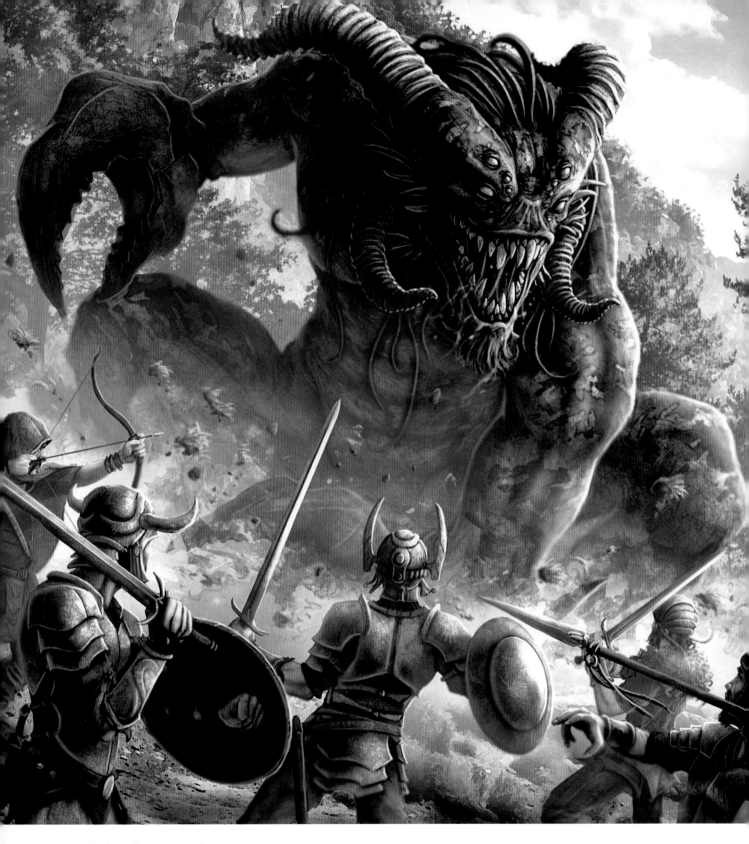

▲ pentaclypse by Kerem Beyit

The drama in this scene comes from the bold composition. The protagonist is the centre of the piece and everything outside of this focal point is reacting to it (the soldiers, the rising dust, even the surrounding foliage). Using humans in the foreground or background of a scene that has a much larger, centrally-placed, foreboding creature in it will play with the viewer's sense of scale. It's the oldest trick in the book.

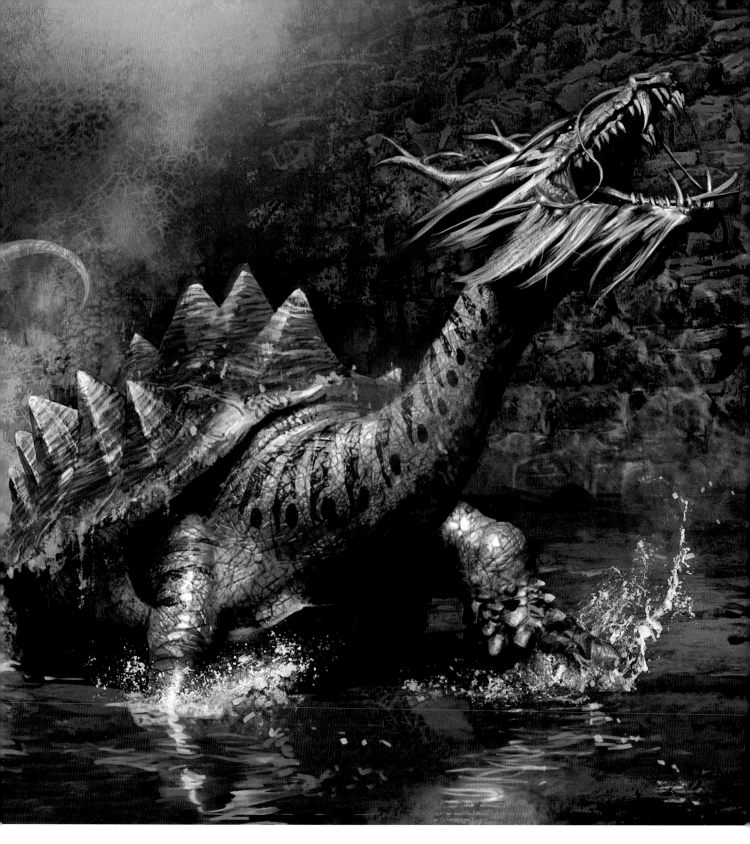

▲ cheldrak by michael komarck

This creature, illustrated for the fantasy game *Legends of Norrath*, is a combination of Chinese style dragon and giant turtle. The artist chose a palette of cool and neutral colours to communicate the cold temperature of a subterranean climate. Since there is no human figure for scale, careful attention was paid to the water turbulence and the stone size on the wall, to ensure they made the creature appear giant. In this case, the lunging attack pose leaves no doubt that this monster has a nasty disposition!

Colour and Light

▼ Landscape sketch no. 13
by grant hiller

The brief from Day 1 Studios was to explore concepts for a hostile environment in a parallel dimension. The artist began work by sketching thumbnail landscapes on a sheet of paper using pencil or ink, exploring interesting shapes and compositions. The ones that were most relevant to the brief were then realized as quick digital speed-paints. Working in black and white at this stage allowed Hiller to focus more on mood, composition, form and depth. For this type of visual brainstorming, it's easier not to worry about colour. The aim here was to establish a good value range and make sure the forms read well. If the art director approves one of these sketches, the artist can move on to a more detailed colour concept.

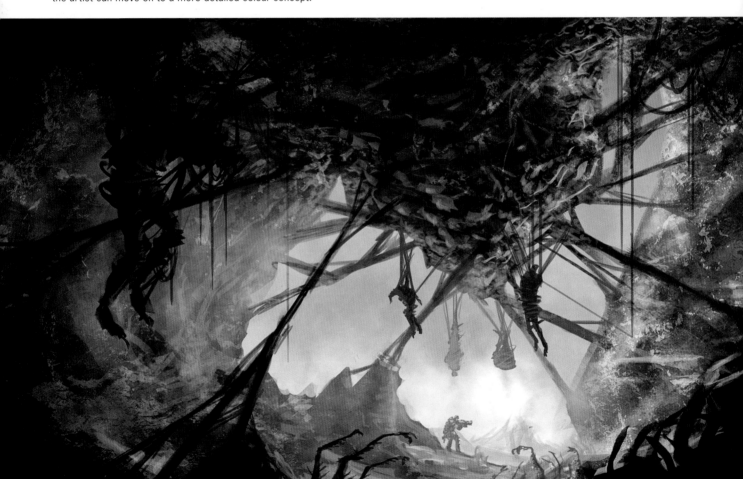

▶ nightmare academy
by J.P. Targete

The artist used the light source to enhance the rich and detailed areas of focus in this piece. Lighting can alter the mood of any scene; it is one of the most powerful tools a level designer and lighter can use to embellish their game levels, but it all begins here in the concept art. Colour is another great attribute. With the present video game technology constantly getting better and higher resolution output becoming the norm, representation of colour within your concepts is vital to express your ideas to your clients.

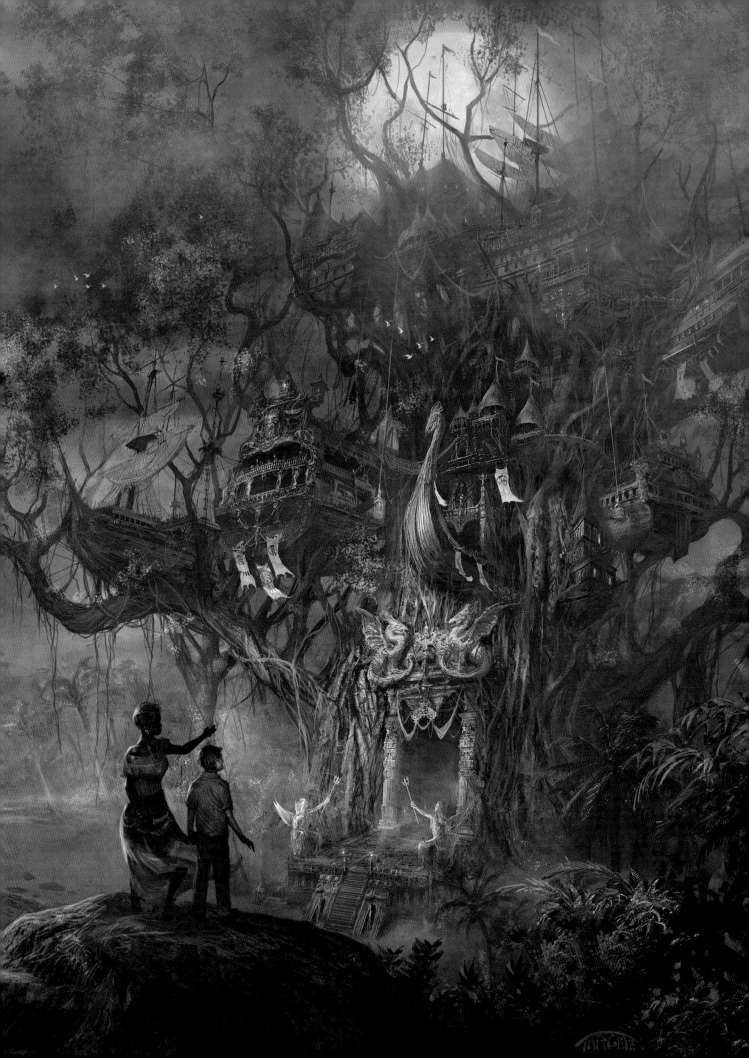

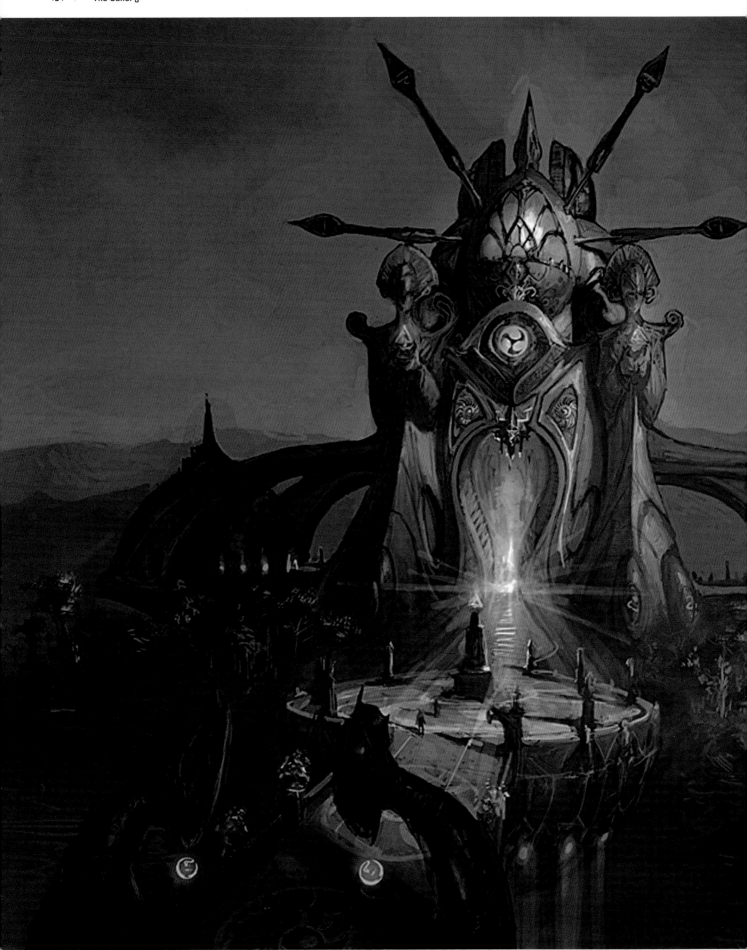

Lost Cities

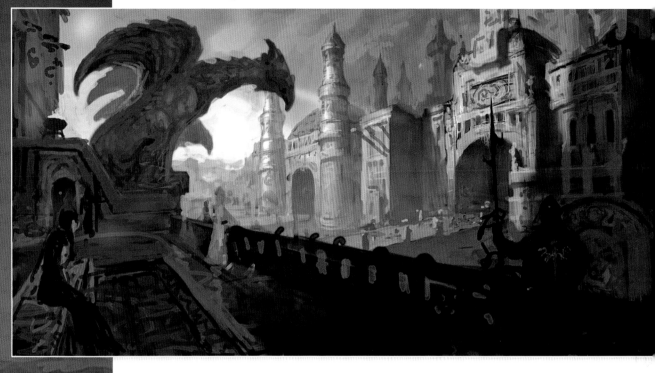

◄ sanctuary
by J.P. Targete

'Sanctuary is a place that can't be reached easily. Like Avalon, this temple only appears in the mist that dawn brings. Secluded on an island on another world, it is a place of peace and serenity. Only those privileged and faithful to its religion are allowed'. The description is more or less what the client wanted. As an artist, you will be challenged with an idea or passage like the one above. But creating a lost city is not as easy as it may seem, and you'll often need to work on several drafts before you get it right. Having said that, it's gratifying when you add the right combo of elements to your scene. From the surrounding body of water to the small trees and ethereal light emanating from the entrance, it all comes together.

▲ castle E3
by J.P. Targete

The grandeur of an ancient rich civilization comes to life in this image. Finding reference for a lost civilization or city is sometimes difficult. Much of your work will consist of imagining it from scratch. The architecture must be fabricated according to themes such as 'the height of a civilization's glory' or 'the downfall of a proud people'. Your architecture must tell the story. Making a populated city look aged or gritty always gives the scene a sense of history and makes viewers feel like they have travelled many miles and discovered their very own lost civilization.

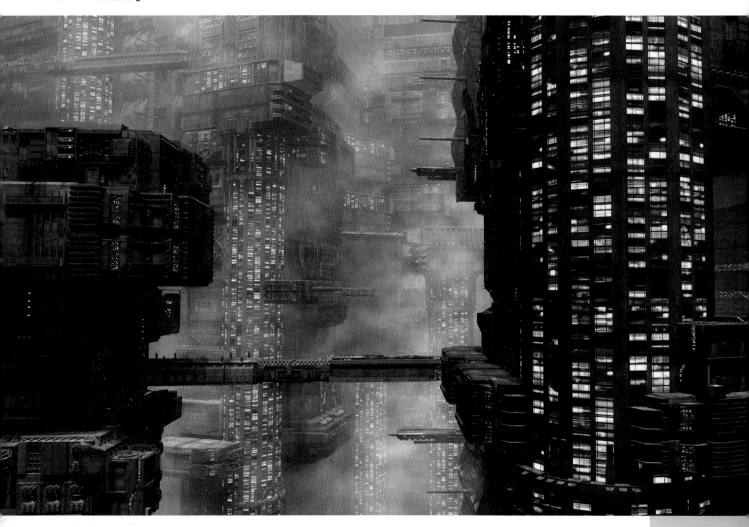

▲ Noisy Neighbours
by Paul Bourne

Bourne's cityscape is claustrophobic and industrial. He began conceptualizing by blocking out large areas with simple shapes until he was happy with the composition. Then he started to add detail, working from the foreground backwards. Note how the details recede into the background. This gives the cityscape depth through forced perspective, but it also kept the polycount low as Bourne worked. Most of the basic modelling was done in Carrara and Zbrush, layout and rendering was done in Bryce, and post-production work was done in Photoshop.

▼ **waterfront property**
by paul bourne

This vast, sprawling urban landscape is made up solely of concrete, glass and steel. Bourne started with a number of compositional sketches that mapped out the city. When he was happy with a layout design, he duplicated the sketch in Bryce, and placed the large domed structures onto a flat plane. These domes then acted as a guide as he built up the rest of the city. Try to build complicated cityscapes from small elements that you can move and swap around. This will give you the freedom to experiment with composition.

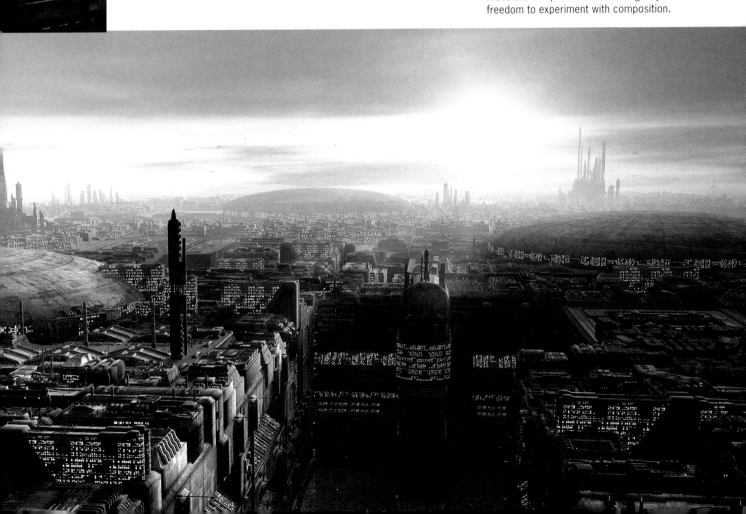

Photoshop File Edit Image Layers Select Filter Analysis View Window Help

Tolerance: 20 ☑ Anti-alias ☑ Configures ☐ Sample All Layers Refine Edge...

DIGITAL TOOLKIT

since almost everything that can
be done in traditional media can
now be rendered in digital media,
it's essential that you have the right
work environment and equipment.
this includes everything from pencils
and pens to graphics tablets and
pixel-based software.

Tue 16:29 **Emma**

Workspace ▾

16 18 20 22 24 26 28 30 32

Navigator ✕ Histogram Info

25%

Color ✕ Swatches Styles

R 0
G 0
B 0

Layers ✕ Channels Paths

Normal Opacity:

Lock: Fill:

Background

sketching in the field: the pencil

All traditional media can be replicated in digital software, and most game artists these days work exclusively on screen. But for excursions or field trips, the old-fashioned pencil is your weapon of choice.

ALL ABOUT PENCILS

Pencil 'leads' are made from graphite, a soft crystalline form of carbon, which is mixed with clay and fired in a kiln. The more graphite a pencil lead contains, the softer and blacker the mark, while a higher clay content makes the lead mark paler. The lead is encased in wood, usually cedar, which is marked on the side with a number and letter classification. 'B' is for black, with more graphite; and 'H' is for hard, with more clay. The higher the number, the softer or harder the pencil, so the highest number, 9B, is extremely soft.

GRAPHITE STICKS

Graphite sticks are shaped like thick pencils without the covering of wood, and are also graded: 2B is a useful average. Some sticks are lacquered for clean use, so scrape them down if you wish to make broad marks, and wrap uncoated sticks in aluminium foil. Graded leads are made for some technical, or propelling, pencils. Office pencils are usually graded HB or B, and ones that make black marks can be used for drawing. Use a sharp craft knife to sharpen them and a flexible, white plastic eraser to remove marks without abrading the paper.

Building up Tone and Texture

Lines can be hatched or cross-hatched to achieve areas of varying density; areas of tone can be scribbled and made darker or lighter depending on the amount of pressure applied. The possibilities are endless but here are some key examples. All these marks can be reproduced using digital software like Photoshop. Corel Painter is particularly good at replicating pencil effects.

Even strokes build tonality with minimal variation. Use consistent pressure.

Rough-edged strokes can be used for a looser rendering style or to indicate a rougher surface.

Vary the pressure with soft pencils. The heavier the pressure, the darker the tone.

Use a sharp 2B-4B pencil to build up tone with rapid cross-hatching. This will create texture through tone.

Use an eraser to produce a softer tonal value, create texture effects, or lift out highlights.

Use a blending stump to even out tones, but use in moderation. The stump can cause unwanted buildup and is difficult to work over.

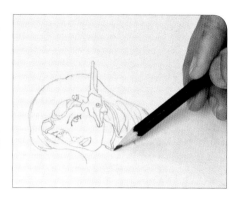

step 1

Make your initial pencil lines with a medium pencil like an HB or F. Keep an even stroke pressure to ensure the line weight is balanced in tone. Too much pressure can score the paper badly, making shading difficult later.

step 2

Work your way down and across the drawing. Be careful not to run your hand over the drawing, as this can smudge or soil the drawing. Take your time, work lightly, and correct any mistakes with an eraser.

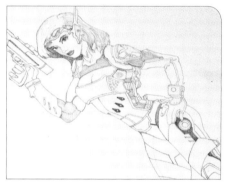

step 3

When you have finished the initial line drawing, reinforce any weak linework. Think about continuity, line weight and resolved form. Everything should fit together and make sense. Don't be afraid to erase and correct at this stage in the game.

step 4

Decide on where the darkest tones go, and fill them with a softer pencil like a 4B. Then use a slightly harder pencil to work back over the shaded area to fill in the tooth of the paper. This keeps it from smudging as well, since you're 'sealing in' the blacks.

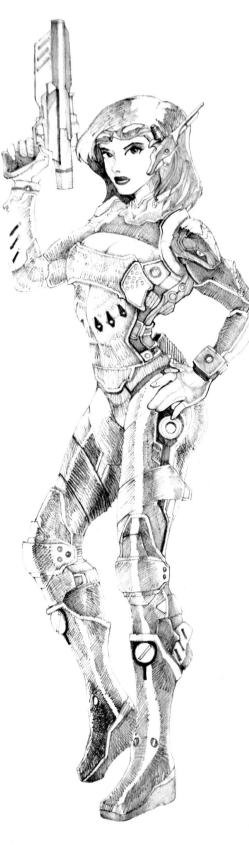

For eyes, pencil in the highlights first and work around them with dark values. Soften the values towards the bottom of the eye.

Remember that the upper lip is usually darker than the lower lip. Try to describe form, not shapes (which are flat).

step 5

Work up the tones using the various techniques opposite. Start light and work your way up. Don't be afraid to go dark, and don't leave out the areas between light and dark. The midtones add detail and give dimension.

step 6

The final piece has both soft and rough rendered textures to indicate the material of the armour. Use a plastic eraser to pick out hard highlights, and a kneaded eraser to pick out softer ones. When working tonally, it helps to squint at your piece, since this helps peel away unnecessary detail so you can address the image's major reads. The eye goes to the point of highest contrast first, so don't be afraid to bully the viewer's eye to where you want it to go.

preparing for scanning: the pen

You may choose to scan your pencil sketch into your computer to colour it digitally. In this case confident, legible linework is essential.

Some scanners may have difficulties 'reading' light pencil drawings. It's best to go over your sketch in pen and ink. You can build up a greyscale sketch in black ink or use a variety of different coloured inks. It depends on whether you want to colour digitally or not.

INKS

Inks come in water-soluble and waterproof versions, and the former can be used like watercolour and diluted with water to produce lighter tones. Acrylic inks can also be diluted with water, becoming waterproof when dry.

Waterproof inks: Non-soluble when dry; denser than non-waterproof varieties; dry to a gloss finish; suitable for precise work.

Non-waterproof inks: Soluable when dry; sink into paper; dry to a matt finish; suitable for laying washes over waterproof-ink work.

Acrylic and watercolour inks: Waterproof when dry; colours are lightfast; used in the same way as waterproof inks but can't be mixed with them.

PENS

Artists' pens come in all shapes and sizes.

Dip pen and nibs: Flexible nibs allow for a range of line thickness and quality; simply vary the pressure.

Bamboo and reed pen: Nib makes a line of a consistent thickness with an irregular, coarse texture. Reed pens can be re-cut and shaped using a sharp knife.

Brush pen: Flexible, brushlike nylon tip that makes fluid calligraphic strokes.

Ballpoint or rollerball: Useful and affordable drawing tools, good for rough sketching and doodling.

Building up tone and texture

When starting to draw in ink, try to make your marks and lines as confidently as you can, even if this means throwing away a drawing and starting again. In this way, you will begin to learn the technical aspects of the medium. Here are some beginners' strokes for you to practise. Again, these marks can be reproduced by most digital software, especially Painter.

Cross-hatch the pen lines to create successively darker and even tones.

Short strokes create an illusion of short stubble or fur. It's a more chaotic stroke, useful for rendering organic surfaces.

Stippling with a pen is the most time-consuming way to create tonality. You get maximum control at the expense of long hours 'filling in'.

The more dense and concentrated areas of your work will appear darker. Try to give a tonal range.

Use white acrylic to correct. It is waterproof when dry, and can be applied with a brush with various levels of opacity.

Contour hatching follows the curve of the object and overlaps to create darker tones, reinforcing the form.

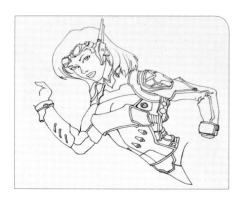

step 1

Lay your paper over the pencil drawing you created following the sequence on page 111. Tape one on top of the other over a glass surface. Shine a light from underneath and trace out your drawing in ink. Alternatively, draw over the pencil lines and erase the pencil.

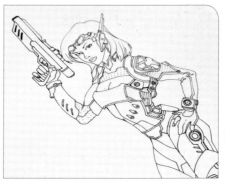

step 2

Render the pencil line equivalent in pen, taking great care not to make any careless strokes. Get the drawing laid out completely before moving to line strength or shading.

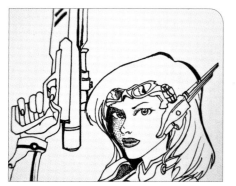

step 3

Start working up the line weight. Think about where the drawing would be darkest and start filling in those areas. In this instance, the light catches the right-hand side of the face, casting the left-hand side into darkness.

step 4

Using a permanent marker or thicker pen, fill in the major areas of the form to pure black. The areas of pure black will act as an anchor for detail that you start to fill in, as here.

step 5

Use hatching to reinforce the form and create surface texture. Think about whether an area is shiny, dull, smooth or rough. Various techniques can be used to reinforce these ideas.

step 6

Decide what areas are pattern and what are shaded. Here dots on the neoprene underarmour are added at regular intervals.

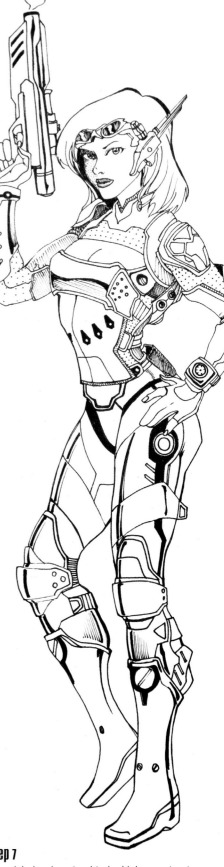

step 7

Since ink drawings tend to be higher contrast than other media, take a few steps back from your work and make sure everything reads correctly. Make sure the line quality reinforces the image, and the blacks don't overwhelm the piece. Now scan into your computer.

digital tools

While some artists will continue to build up their work using traditional media such as watercolour or acrylics, most will 'go digital' at this point. You've enjoyed the spontaneity of applying pencil or charcoal to paper but now you can exploit the technology of painting software to create images that would not be possible in traditional media alone. First you'll need the right kit.

DIGITAL CANVASSES

The choice of computer is yours. The Mac is the primary platform for cinematic editing and for print media, but for game asset development, it is the PC. Most PC operating systems include a program that allows you to draw, paint and edit images. Download a trial version of Photoshop or one of the many free digital painting programs such as ArtRage, Pixia or MyPaint.

DIGITAL PAINTING

Many artists just dive into 3D and create designs on the fly without planning from a sketch. The process is fresh and evolving and without limitations. A vital piece of equipment if you prefer this approach is a stylus and graphics tablet. A stylus replicates the natural drawing movement. Tablets come in a range of sizes, with commensurate differences in price, but smaller ones are well within the budget of most artists. Digital art brushes replicate actual brush strokes. For this reason, many game studios are bypassing 2D concepting altogether, creating instead a 'concept sculpt'. This is especially the case if fast 3D prototyping and animation testing is required by the tech team.

OTHER TOOLS AND EQUIPMENT

Scanners are a worthwhile investment as they often include a basic photo-editing and drawing package or a reduced version of one of the professional packages. A cheap digital camera is a powerful weapon, as it can be used either to gather reference material, or to take images that can be digitally manipulated and worked into your environments.

ESSENTIAL ITEMS

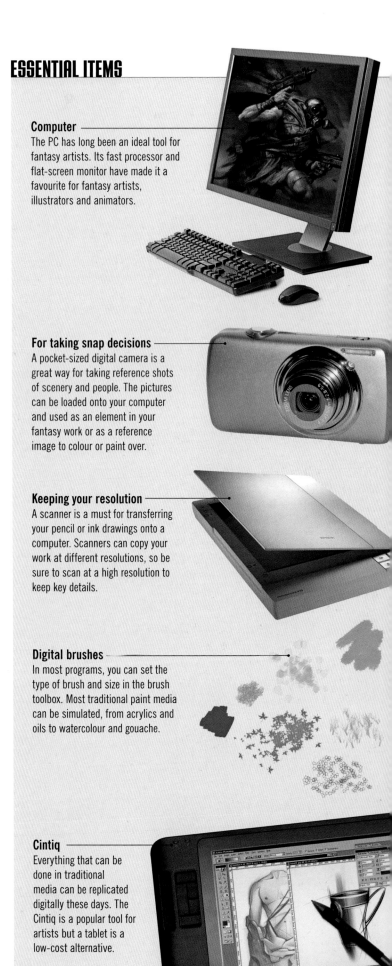

Computer
The PC has long been an ideal tool for fantasy artists. Its fast processor and flat-screen monitor have made it a favourite for fantasy artists, illustrators and animators.

For taking snap decisions
A pocket-sized digital camera is a great way for taking reference shots of scenery and people. The pictures can be loaded onto your computer and used as an element in your fantasy work or as a reference image to colour or paint over.

Keeping your resolution
A scanner is a must for transferring your pencil or ink drawings onto a computer. Scanners can copy your work at different resolutions, so be sure to scan at a high resolution to keep key details.

Digital brushes
In most programs, you can set the type of brush and size in the brush toolbox. Most traditional paint media can be simulated, from acrylics and oils to watercolour and gouache.

Cintiq
Everything that can be done in traditional media can be replicated digitally these days. The Cintiq is a popular tool for artists but a tablet is a low-cost alternative.

software options

Outlined below are the key competitive illustration software packages for both 2D and 3D rendering. If you need in-depth information when making your selections, refer to a manual or online help.

PHOTOSHOP OR PAINTER?

Pixel-based software uses small amounts of data to represent a pixel on-screen, making it ideal for photos and paintings. Adobe Photoshop is the favourite pixel-based software of many fantasy artists.
It has been used throughout the book to illustrate digital painting techniques, but there are many alternative programs you may wish to consider and Corel Painter in particular is a strong competitor and a viable alternative. See the panel at right for some useful distinctions between the two.

OTHER SOFTWARE

Illustrator: Adobe Illustrator uses maths equations and PostScript language to produce drawings. Very small files are created, which contain images that can be enlarged without compromising quality.
Pixologic ZBrush and Autodesk Mudbox: High-detail sculpting programs replicate the feeling of working in clay with a variety of moulding tools. You can save multiple layers of detail and build up your creation in stages that are saved along the way. These programs come with some starter models to manipulate.
Autodesk Maya and Autodesk 3ds Max: These software packages feature comprehensive tools for the game artist: 3D modelling, shader and texture work, cloth simulation, visual effects, image rendering and more. They also both have a full suite of animation tools. Each product is basically a full end-to-end creation tool chain for the artist. Though once released by separate companies, both are now under the Autodesk banner. Maya is popular in the TV and film industry for tasks such as creating visual effects, movie pre-visualizations and 3D animation.

SOFTWARE BARGAINS

Upgrading to more sophisticated software can burn a hole in your pocket. Software downloads and free trials are the best bargain, since you can sample them before paying a fee. Most software packages offer 30-day trial versions for free download, including ArtRage, Pixia and MyPaint, which are excellent for image creation. SketchUp by Google and Blender are free 3D programs. Download a selection of programs offering free trials before you commit to one.

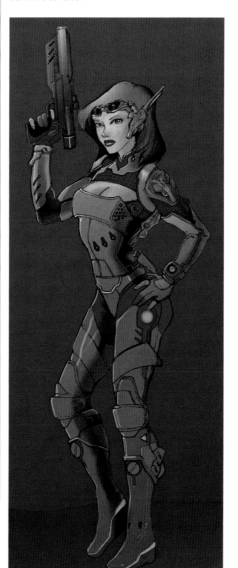

◄ digital colouring

Digital colouring is quick and effective, and the digital brush is fast becoming the rendering tool of choice for fantasy artists worldwide.

PROS AND CONS OF PAINTER

- Painter simulates natural media. It has nearly any type of natural media brush available, in nearly any setting
- Canvas can be rotated easily, like a piece of paper, and brush sizes are adjustable (hold down ctrl+alt and drag out the size you want)
- Colour picker is set in a colour wheel fashion, which is intuitive
- Custom brush creator is robust
- Custom papers can be imported and are easily modified
- Slows down during heavy layer usage
- Sheer numbers of brushes, papers, brush settings, layer types, and the interface in general can be overwhelming for some

PROS AND CONS OF PHOTOSHOP

- Brush creator isn't nearly as intimidating as in Painter and it is powerful and time-efficient
- Formatting options are intuitive
- Can mimic natural media fairly well, but it's more complicated than Painter and you'll need to tweak your brush settings or create new brushes from scratch. The default brushes that are given with a fresh install are limited in quantity and function
- Layer settings such as hard light, multiply, soft light, etc. can be extremely useful. The layer system can handle vast amounts of layer data and allows for a great deal of 'nondestructive editing'
- No autosave function

adobe photoshop in detail

There is no other software covering as broad a range of tool sets as Photoshop. It has become, since its first use in game art departments 20 years ago, a standard in the game industry.

Familiarity with absolutely all of the tools in Photoshop is not obligatory. The digital fantasy artist should understand how to use painting and drawing tools, selection tools, filters and layers, and be familiar with some of the image menus.

PAINTING AND DRAWING TOOLS

For digital inking, you can use the Brush or Pen tools – your choice will be dictated by your hardware and by your hand. If you have a graphics tablet, the Brush tool is the better choice as the stylus will create clean, natural-looking lines like a real ink pen or brush. If you're using a mouse, the Pen tool is preferable: it uses vectors to create the lines, producing smooth curves that remain editable as you work.

Your pen lines will be found in the Paths palette. You will need to save them, rather than leaving them as 'work paths'. You can also save separate paths for each object. Establishing good working practices like this will make your job much easier.

◄ pen options
Setting the Pen options to use Rubber Band lets you see exactly where a path is being created as you do it. You will also need to select the other options shaded here, especially when working with a mouse.

ACTION SETS

The Action Set recording feature automates tasks. This may mean renaming several files at once, or changing their attributes, converting the format, or altering image size. Actions are fundamental to projects where many images require a similar look. Basic steps in altering a scanned image, such as loading a selection and using a colour fill to alter the image, can be a recorded as an action set.

Use the Actions palette to record, play, edit and delete individual actions. This palette also lets you save and load action files. Playing an action executes the action's recorded commands in the active document. You can exclude specific commands from an action by checking or unchecking the box next to each action, or play only a single command. You can record operations that you perform with the selection vector tools, as well as the Crop, Slice, Magic Eraser, Gradient, Paint Bucket, Type, Shape, Notes, Eyedropper and Colour Sampler tools, and can record Colour, Paths, Channels, Layers and Styles. When you create a new action, the commands and tools you use are added to the action until you stop the recording.

Action Sets for the fantasy artist might be a combination of artistic filters and blended layers, similar to the sets pictured right where a colour application would be useful to give an army of creatures a similar style.

original artwork
The original drawing is scanned in and opened in Photoshop.

PHOTOSHOP INTERFACE

If you are new to Photoshop, familiarize yourself with the layout and the principal tools you will need to ink and colour drawings digitally.

❶ Paint Bucket and Blend

❷ Pen

❸ Brush and Pencil

❹ Magic Wand

❺ Tools options

❻ Colour Swatches palette

❼ Layers and Paths palette; blue shows active layer

❽ Info menu button showing the RGB and CMYK colour values of a selected area

Poster Edge filter setting

A Poster Edge Filter is applied to the scan of the original drawing. The Poster Edge Filter has three settings that enhance the lines on an image: Edge Thickness, Edge Intensity and Posterization. Here, the Edge Thickness is set to 0, Edge Intensity to 1 and Posterization to 2. Save these settings, and you can apply this treatment to an entire alien army.

Transparent selection

The original is coloured using Transparent Selection to mask a new colour layer, and blended using Pin Light, which gives it an iridescent glow. There are five steps saved as the 'action': set the selection to Transparent; select the foreground colour; make a new layer and fill the selection; set the blending mode (Pin Light); and merge the layers.

MAKING PATHS

To create a path with your mouse, click at a suitable point (such as a corner), then at another point, holding down the mouse button and dragging to create a curve. Repeat until you return to your starting point or reach the end of the line. The lines can be fine-tuned by adjusting the 'handles' at the click points.

FROM PATHS TO LINES

Once you have drawn paths over your pencil drawing, you need to add black lines to the drawing. Start by making a new layer in the Layers palette, so as not to make the lines part of the original drawing. Make sure the foreground colour is set to 100 per cent black.

▲ **step 1**
Scan in your original artwork.

▲ **step 2**
Select the Brush tool.

▲ **step 3**
From the Brushes menu, select an appropriate brush size for the line.

▲ **step 4**
Select a path, then 'Stroke Path' or 'Subpath' from the Paths palette's menu.

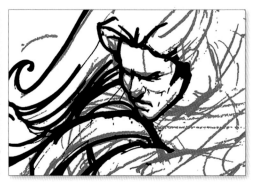

▲ **step 5**
This will apply a three-pixel line along the selected path. To add a thicker line, change the brush size and repeat.

MASKS

Masks are a very useful feature with which you should familiarize yourself. These work like digital Frisket, a film used by airbrush artists to block areas that are not to be coloured. Photoshop masks can be applied to individual layers.

▶ **quick mask**
A quick way to mask an area is to use the Magic Wand tool. Simply click in the relevant area, as with the Paint Bucket. This will create a selection that will be the only active area on the layer, so you can use a large airbrush along an edge and keep it contained to where you want it.

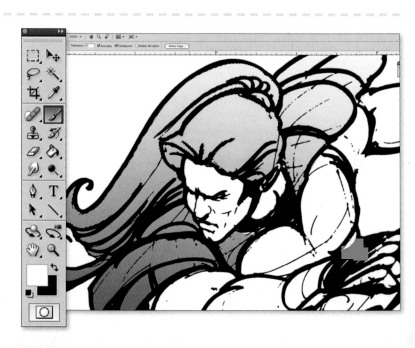

COLOURING YOUR IMAGE

Once you have 'inked' your drawing, you will want to colour it. For printing, you will need to work in four-colour or CMYK (Cyan, Magenta, Yellow and Key Black); work in RGB (Red, Green and Blue) if it is for screen only. Note that a lot of Photoshop filters work only in RGB mode.

Another thing to be aware of is your black lines. If you have inked in greyscale, once you convert to CMYK, it will create a composite black (known as process black or rich black) made up of the four process colours. The advantage of this is that, when the linework is placed over the colour, you will not get 'show through' – something that happens if you place just 100 per cent black over colour. This is because the black ink is the last to be printed. If you are placing lettering in your image, use 100 per cent black rather than process black because this will make it easier for a printer to produce different language texts.

▲ colour swatches

When working over a series of drawings, it is a good idea to create a palette of colours that can be loaded at any time, to keep your colouring consistent. Choose Save Swatches from the Swatches menu and give it a name. To bring the swatch into a job, use Load Swatches from the same menu.

◀ Multiply layer

In the Layers palette, set the blending mode to Multiply. This will make the white area act as if it is transparent, while retaining the black lines and any shading.

▲ change of mode

Greyscale or bitmap images need to be changed to a colour mode: CMYK for print or RGB for screen (or for using particular filters and effects).

▲ curves

Blacks are converted to CMYK or RGB equivalents. If you are working with process colours, adjust the curve for the black channel of the linework layer to bring it up to 100.

▲ paint Bucket fill

The fastest way to get colour into your image is with the Paint Bucket. Create a layer for the colour or object and select All Layers in the tool options. The amount of tolerance you set will depend on your linework. In this example, there are some pale pencil lines left to add tone, so setting the tolerance high ensures that all the area is filled. Anything missed can easily be touched up.

Layering

Every form of art has a layering element to it. Visual artists create layers: the blank surface, the sketch, the first wash of colour and so on. The process is, for the most part, irreversible. Using the layers menu in Photoshop can replicate the process of creating a traditional painted image, but for every application of colour, wash or highlight, there is a separate, undoable layer. Here, an early concept sketch for *Tomb Raider* is built up in layers, using the selection masks shown in the menu.

step 1

An early concept sketch is scanned in and placed on layer one over a white background. The interior elements are filled in using selection masks, shown in the layer menu. The bright highlights on the edge of the two foreground ruins were painted on as a separate layer.

The scanned-in sketch fragments.

The remainder of the room is sketched out roughly in Photoshop.

Each layer is like a cut-out photo that is not yet stuck down.

step 2

The next steps involve the placement of image elements from an archive of Mayan statuary and stonework. With the foundation layer providing shading and an indication of stonework and carving, use the selection masks from the shapes in the scene and paste into the selections the scraps of Mayan stone or carving. Each of the pieces is transformed, scaled, rotated, distorted to fit as closely as possible to the shape under it, and blended to enhance the underlying shading and line.

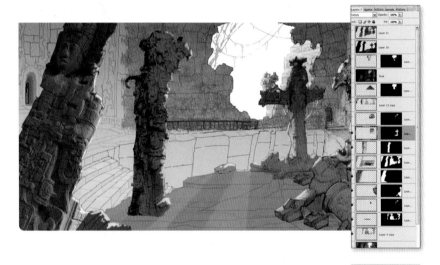

step 3

Further photographic image elements (such as the colonnades in the pit and the inscriptions on the far wall) are added on a separate layer. Action sets are activated to sharpen line detail.

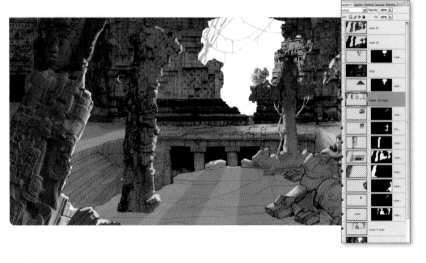

step 4

A new layer is created for the mountain in the background. It's paler than the rest of the foreground images to give a sense of distance and perspective. This is done using editing effects and filters (see pages 122–123).

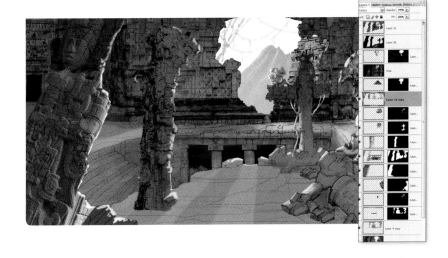

step 5

The primary light source is coming from the hole in the back wall, which casts the foreground ruins in darkness. This creates an ominous and unsettling atmosphere which is developed further in the next step, when things like temperature, time of day, and weather are all taken into consideration.

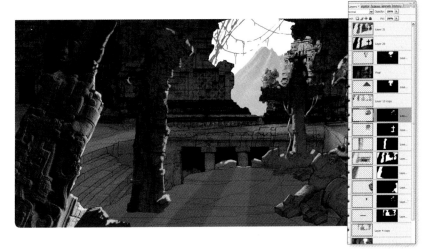

step 6

Haze and smoke are added using brushes at 30 per cent opacity, then blurred and smudged until the desired effect is achieved. A layer of fire is added to the foreground rubble and the colour of its light is brushed over nearby surfaces. Pools of water are added to the foreground reflecting elements around it. The water layers are made with the selection tools, the Ellipse and Lasso, and filled with a colour that fits the lighting, then blended with overlay and soft light, erased and faded until the water layer fits the scene. The background mountain is blended into the opening.

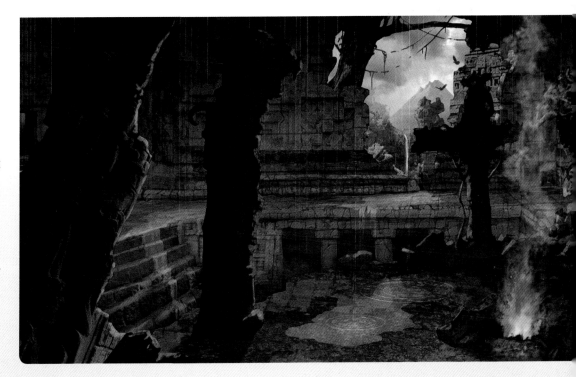

artistic filters

There are several artistic filters that offer painterly and graphic effects. The Artistic Filters section of the Filters menu has fifteen different painterly and graphic effects, each with its own settings. The Dry Brush, Coloured Pencil, Palette Knife, Rough Pastels and Paint Daubs effects are the most useful to the digital fantasy artist.

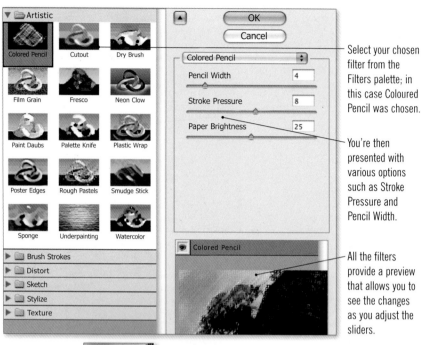

Select your chosen filter from the Filters palette; in this case Coloured Pencil was chosen.

You're then presented with various options such as Stroke Pressure and Pencil Width.

All the filters provide a preview that allows you to see the changes as you adjust the sliders.

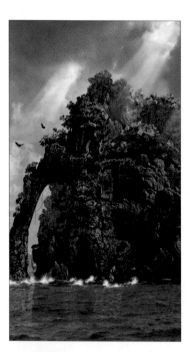

◄ original

This is the concept for a coastal temple. Before any filters are applied the detailed original is saved; copies are used for experimentation with filters.

◄ rough pastels

In areas of bright colour, the chalk appears thick with little texture; in darker areas, the chalk appears grainy to reveal the canvas effect beneath. The effect will be like rain and wind, distorting the player's vision in the game.

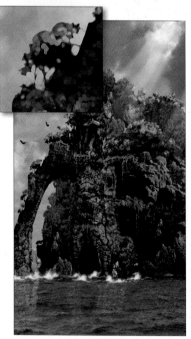

◄ paint daubs

The Paint Daubs application allows you to choose brush sizes (from 1 to 50) and brush types for a painterly effect. At these settings, it delivers a classical oil painting effect, like a pastoral landscape, but by adjusting the brush size and sharpness, you can create quite different moods. With the sharpness set at zero, for example, the brush holds the detail and softens the overall appearance.

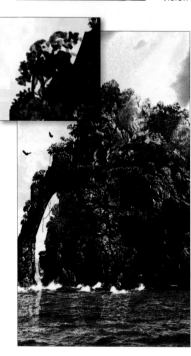

◄ smudge stick

The Smudge Stick softens an image by using short diagonal strokes to blend the darker areas. Lighter areas become brighter and lose detail. The effect is like a tropical storm.

editing modes

There are various editing modes that will help you to create atmospheric fantasy art. The original image here was 'smudged', 'gradated', 'erased', and 'adjusted', but these are just a few editing modes available to you when working in PS.

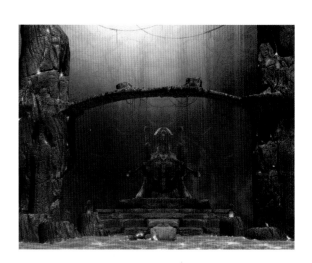

▶ original image

This image required further embellishments to create atmosphere. The image is saved as one layer in Photoshop and then manipulated using numerous editing modes, as outlined below. Each 'edit' is saved in a new layer so that it is easily reversible.

▼ final image

The swords of flame in the image below might play an important role in a game scenario, appearing only when the player gets too close to the statue for example. Notice how much stronger the image is as a result of this added interest. The swords balance the composition and heighten the sense of danger. Finishing touches like these often hold the key to the whole game.

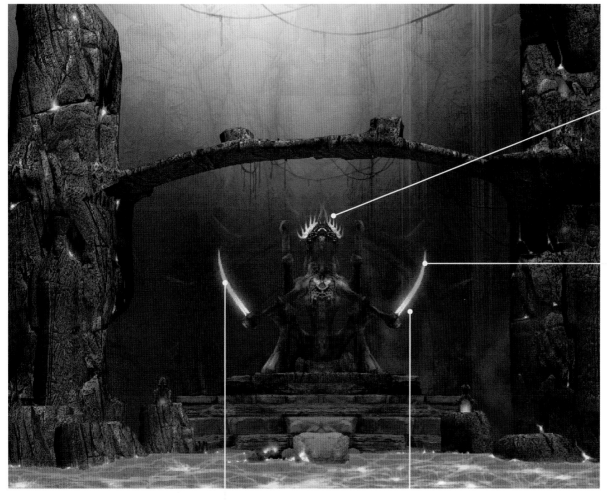

The Smudge tool is used to make the flame shapes on the crown. The layer is then blended using the Colour Dodge mode for a jewelled glow.

The sword was created as a separate layer. The outline is drawn with the Lasso tool and then filled with a bright yellow colour.

To create the second sword, copy and paste the first blade selection. Flip and place the duplicate.

The flames around the edges of the sword are the work of the Smudge tool, which has the same effect as rubbing your finger in paint to blur a neat line.

creating a winning portfolio

So you've been working hard and have accumulated quite a few pieces of work you are proud to show. Now you're ready to build a winning portfolio. Here, we show you how.

To create a portfolio to share with potential employers you will want to present your very best work in a format that is easy to view and understand. First decide the type of work you do best and select samples that reflect your talents.

WHAT SHOULD MY PORTFOLIO CONSIST OF?

A well-rounded portfolio should show some illustration and concept work; this can also include life drawing. This will let your potential future employer know that you have strong basic skills. There are many types of skill sets needed in game development, but foundation skills are applicable to everything you do. So even if you are a novice in 3D work, include evidence of your drawing skills and you will communicate your true potential.

Include examples of both environment and figure work, but remember to show only your best. It is better to show a number of characters in one theme. This will let your reviewer know that you can create multiple characters in one style. For example, let's imagine you have illustrated a series of characters for a game about surviving in a post-apocalyptic world. A lineup of the

heroic characters in this game might consist of: a large brutish warrior, a tall, skinny nerdy scientist and a young athletic female. Three very different characters rendered in the same art style will show you can create more than just a few 'one-of-a-kind' pieces. Treat environments in the same way.

HOW MUCH ART SHOULD I INCLUDE?

Choose between ten and twenty pieces to present and only show your best work. Remember that your work may be viewed by many people and you must assume that you will not be present to narrate details about what you included and why. This is important because you will often be judged on the weakest piece in your portfolio. For example, you may have ten fantastic 3D models and have also tried your hand at animation. Your animation work is not up to the same high quality, but the evaluator can only assume you think it is just as good as your 3D work and call into question your ability to recognize what good work consists of. Save that for a face-to-face interview where you can explain that you have also tried some animation and, though you are just getting started, you are eager to learn and grow. A piece of sub-par art can cause an evaluator to pass on you.

DO I NEED TO QUALIFY MY ART WITH TEXT?

Include some brief text explanation when necessary but assume that many people will page quickly through your work if they are looking through several portfolios in one sitting. Once they have

▼ presenting your character work

A portfolio containing character designs should have several characters that look like they belong in the same game, so that you can show your skill in creating multiple characters in a specific style.

http://www.fantasyartistsonline.com

CHARACTER DESIGNS

decided they like your stuff, they are going to take a more detailed look at your explanations and so these should enhance their visual experience and give additional details. Short and informative information such as a project title, software used, texture size and polygon count is enough.

PRESENTING 3D WORK AND ANIMATION

When showing 3D work, it is important to present it 'in the round'. Showing a model in an action pose is best and, if possible, show your work in rotation by creating a movie file where the character or object rotates 360 degrees. Show construction details as well as your finished work. If you are presenting still shots, show the completed character and the mesh – so that a reviewer can see you have good mesh construction skills. Show your texture map images (see page 80) in their flat form, so that the reviewer can see that you used the texture space efficiently. This will give the reviewer confidence that you understand and practise solid construction methods.

If you are showcasing animation, you should present a 'run-and-walk' cycle. This is a baseline standard for animation. Make sure it is smooth and convincing with no hitches when played in a continuous loop. You should also include plenty of action moves and a series of a character 'emotes'. Emotes are short gestures that bring a character to life such as: an excited cheer, an angry fist wave, crying, laughing; anything that brings the static model to emotional life.

PRESENTATION FORMATS

The best way to get your work seen and circulated through a company is to present it on a webpage or blog. Your work can be easily viewed and forwarded as a link in an email. Do make your page easy to navigate and use standard file formats. Don't make it restrictive so that a reviewer has to enter passwords or download any uncommon programs or video codices to view your work. Your website or blog should contain: a short bio that explains who you are, the type of work your site contains, and why you are passionate about creating art for games.

JOB HUNTING

When you respond to a job posting or enquire about positions available, make sure your email includes a more detailed version of your bio along with specifics as to why you would be a great choice for the company you are applying to. This is called the

PORTFOLIO CHECKLIST

Your portfolio presentation should include:
- Your contact information: name, email and phone number
- Short bio that explains why you are passionate about creating your work and your goals for a career in game development
- Traditional illustration work, including the human form
- Examples of the work you are best at: illustration, 3D modelling or animation
- List of the software you are proficient in using
- List of any prior work you have created for a client

cover letter. The cover letter is your chance to state why you are a good choice for this particular company, so it should contain specifics that show you understand the kind of games the company makes. Do some research, look at the company's website, and make sure you are familiar with its games and history. Read some reviews on the games and check some out for rental or see if there are some free-download demos.

WHERE CAN I GO FOR MORE INFORMATION?

There are some good websites to consult to learn more about the game industry, its jobs and how to get started.
- Game Career Guide (**www.gamecareerguide.com**). Job postings section, a digital tutor feature that matches students to art schools and regular feature articles dealing with careers.
- Game Developer Magazine (**www.gdmag.com/homepage. htm**). A monthly publication for professionals with articles covering all aspects of game development, including an annual salary survey issue.
- DeviantART (**www.deviantart.com**). Get feedback and look at work being done by other artists, create a personal gallery and profile, and share your work with others for comment and critique. Often job openings get discovered through word of mouth on social networking sites like these.

index

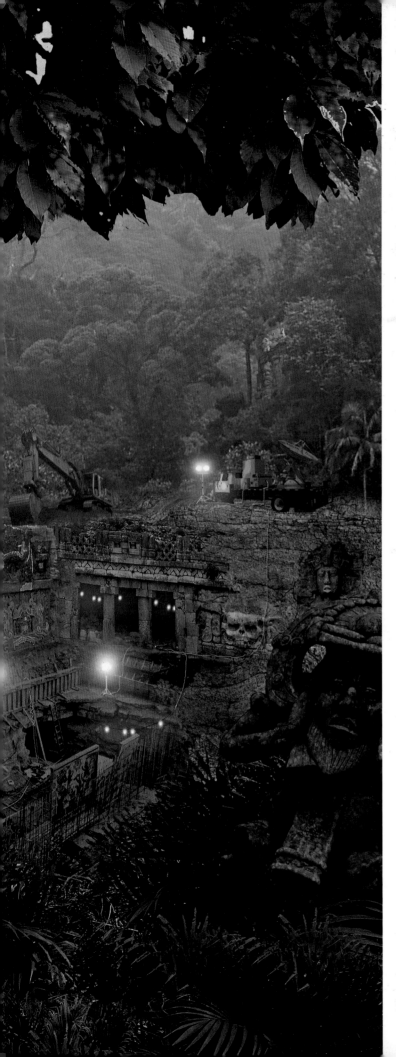

credits

Quarto would like to thank the following artists for kindly supplying images for inclusion in this book:

- Rob Alexander: 14br, 14bl, 16br, 16bl
- Daniel Cabuco: 110–111, 112–113, 114
 Lead character artist, *Tomb Raider: Legend*
- Brad Fraunfelter: 19, 20
 www.bradfraunfelterillustration.com.
 For more details contact: brademail99@yahoo.com
- Shaun Mooney: 62–67, 72–73
- Linda Ravenscroft: 35l
 www.lindaravenscroft.com
- Joshua Staub: 40–41
 www.joshstaub.com
- J.P. Targete: 12–13, 25t, 30, 31t, 32-33, 36, 38–39, 47br, 49, 53tl
 www.targeteart.com.
 For more details contact: artmanagement@targeteart.com
- Roel Wielinga: 26, 27, 28–29, 117t, 118–119

All other artists are credited beside their work. Kerem Beyit; Grant Hiller, www.artjunkiefix.blogspot.com; Michael Komarck; Daryl Mandryk, www.mandrykart.wordpress.com; Lee Petty, www.leepetty.blogspot. com. Thanks also to Thom Hutchinson for his script treatments, featured on pages 18 and 21. With special thanks to Joe Shoopack and the following artists at Sony Online Entertainment LLC:

- Dave Brown II
- Floyd Bishop
- Matt Case
- Patrick Dailey
- Gary Daugherty
- Tad Ehrlich
- Patrick Ho
- Roel Jovellanos
- Steve Merghart
- Edwin Rosell
- Cory Rohlfs
- Tom Tobey